Philadelphia
THEN AND NOW

60 Sites Photographed in the Past and Present

TEXT BY

Kenneth Finkel

•

CONTEMPORARY PHOTOGRAPHS BY

Susan Oyama

•

PRINT DEPARTMENT
THE LIBRARY COMPANY OF PHILADELPHIA

Published in Cooperation with
The Library Company of Philadelphia by
Dover Publications, Inc., New York

For our parents
Morris and Miriam Finkel
Kazuo and Setsuko Oyama

———————

Published in Canada by General Publishing Company, Ltd.,
30 Lesmill Road, Don Mills, Toronto, Ontario.
Published in the United Kingdom by Constable and Company, Ltd.,
10 Orange Street, London WC2H 7EG.

Philadelphia Then and Now: 60 Sites Photographed in the Past and Present
is a new work, first published by Dover Publications, Inc., in 1988,
in conjunction with the Library Company of Philadelphia.

Manufactured in the United States of America
Dover Publications, Inc., 31 East 2nd Street, Mineola, N.Y. 11501

Library of Congress Cataloging-in-Publication Data

Finkel, Kenneth.
Philadelphia then and now.

1. Philadelphia (Pa.)—Description—1981- —Views.
2. Historic sites—Pennsylvania—Philadelphia—Pictorial works.
I. Oyama, Susan (Susan Kazuyo), 1957- . II. Title.
F158.37.F56 1988 974.8'11 88-18957
ISBN 0-486-25790-8 (pbk.)

PREFACE

The Library Company of Philadelphia, founded in 1731, was 135 years old when it first acquired a substantial collection of Philadelphia prints and photographs. It was 1866. The era when the library served the Constitutional Convention and then Congress was long over. The old institutional memory was fading as the new industrial city was rising. It was time to make a visual record of the past.

We have built on this strength. Twenty thousand vintage Philadelphia photographs were added to the collection in the last decade. When Dover Publications suggested that we consider this book, we did not hesitate.

Thousands of images were reviewed and hundreds of sites were visited to determine changes since the time of the vintage photographs. Eventually, we winnowed the group down to 60 views by various nineteenth- and early twentieth-century photographers.

Of the 60 vintage views, 53 were among the recent acquisitions. Some were gifts of S. Marguerite Brenner, Joseph J. Kelly, Margaret Odewalt Sweeney, Robert M. Vogel and the Barra Foundation. Others were purchased from Andrew Cahan, S. Richard Calhoun, Paul Cava, Charles Isaacs, Ralph Jennings, the George S. MacManus Company, Richard Rosenthal, William L. Schaeffer and The Philadelphia Print Shop, Ltd.

To produce the matching "now" photographs, we located the vantage point of the earlier photographers and duplicated their angle of view. We visited each location with a copy of the original "then" photograph, considered the details and placed our tripod accordingly. To match the angle of view, we mounted a tracing of the vintage photograph (prepared earlier on clear acetate) onto the viewing glass of our 4×5 view camera. Looking under the black cloth, we saw the scene from "now" projected onto the tracing of the scene from "then." Final alignments were made and several exposures were taken.

Nineteenth-century photographers faced technical problems inherent in cumbersome camera equipment and inconvenient processing. Before the 1880s, negatives had to be exposed and developed while wet. When Robert Newell photographed Markley's Tavern in the 1870s (page 50), he packed his horse-drawn darkroom and drove it out of town on the dirt-road extension of Broad Street. When he got to the hotel, Newell sensitized a large glass negative in his parked wagon, carried it to his camera, exposed it and then processed it before moving on.

The problems we faced were more logistical. Today, Broad Street is a major thoroughfare joining the center of Philadelphia with the northern suburbs. No horse-drawn darkroom for us. We photographed from a narrow island in the middle of 35 m.p.h. traffic. Obstacles such as parked trucks, utility poles, road construction and trees often blocked our view entirely or compromised our position. It did not take long for us to realize that the urban street scene was a difficult place in which to work.

To photograph the recently lit Benjamin Franklin Bridge (page 3), we were obliged to pass through the Riverfront State Prison in Camden, New Jersey. Special permits were required. A prison guard escorted our crew to the Delaware riverbank. Engineers from the Delaware River Port Authority agreed to illuminate the bridge earlier than usual, but fortune was hardly so cooperative. Inclement weather forced 20 cancellations. Further delays were caused by malfunctions of the bridge lights. By January 1988, the lights of One Liberty Place were part of the night skyline.

Photographing from ledges and rooftops tested our nerves. But it was the interior of the Library Company's own former home, the Ridgway building (page 33), that proved the greatest problem. The building, abandoned, sealed off from sunlight and without functioning electrical outlets, offered us no choice but to haul in two generators and a dozen lights. Preparation and set-up took a day and a half. The photography was completed in 20 minutes.

We are grateful to the City of Philadelphia and its Departments of Public Property, Streets and Recreation for permissions. We thank John Rubbo, Division of Building Services, Joseph Brogan and Robert Murray, and the City Representative's Office. We thank Jeff Brown of the Philadelphia Redevelopment Authority, the kind folks at the Delaware River Port Authority's Engineering Department, John Alviti and Jeffrey Ray of the Atwater Kent Museum, and the helpful staff at the Free Library of Philadelphia.

Many others made shots possible. We thank the Children's Seashore House, Coldwell Banker Real Estate/Management Services, Equifax, Inc., Fannie Mae of Philadelphia, The Gallery at Market East, George School, Franklin Institute, Humphrys Flag Company, Independence National Historical Park, Institute of Pennsylvania Hospital, Pam Kelly, Penn Mutual Life Insurance Company, Philadelphia Girls Rowing Club, Philadelphia Saving Fund Society, Riverfront State Prison and Robert Wise Management Co., Inc.

Robert Asman, Will Brown, Hugh Tifft and Geri M. Tuckett helped, expertly and patiently, with the copy work and printing.

Research for the text that accompanies the photographs

was done largely at the Library Company of Philadelphia and Historical Society of Pennsylvania. When we could not find what we needed, assistance was generously volunteered by many, including Edmund N. Bacon, Barron Bohnet, Jeffrey A. Cohen, David C. G. Dutcher, Fairmount Park Commission, Ellen Freedman, David Hollenberg of John Millner Associates, Steven Izenour of Venturi, Rauch and Scott Brown, Patrice Lajeunesse of the Mummers' Museum, George E. Patton, Charles E. Rosenberg, Marciarose Shestack of the William Penn Restoration Committee, Father Mark Shinn, George Thomas, Richard Tyler and the Philadephia Historical Commission, Rafael Villamil, The Wildlife Preservation Trust International, Inc. and Edwin Wolf II.

Funding for the project has been provided by the William and Flora Hewlett Foundation and the Quaker Chemical Foundation.

We are thankful to John C. Van Horne, the staff and Board of Directors of the Library Company. We received special help from Jennifer Woods. Gordon Marshall was the technical wizard for difficult shots. Geri M. Tuckett's assistance in every phase of the photographic work helped the project go smoothly; we thank her.

Our spouses, Margaret O. Kirk and Jeffrey Hurwitz, offered support and patience when needed most. Jeff's expertise in lighting, photochemistry and equipment, and his help on the most challenging shots, made a substantial contribution. Margaret's editorial eye and her ability to help turn mere words into writing brought drafts out of the Dark Ages. We are indebted to them.

INTRODUCTION

We know what South Broad Street looks like today. The sun slices between office buildings. It lights up the marble tower of City Hall. Cars and trucks dominate at ground level; subways rumble below. We overhear sidewalk conversations about office politics, Caribbean vacations, variable mortgage rates.

What was this scene like in 1888? From surviving photographs, we can see that City Hall was still under construction. Its new sculptures gleamed in the sun; the tower was not yet visible. Strung along the pavement was a hotel, a club, a church and a mansion. Horse-drawn carriages and delivery wagons on cobblestones must have filled the air with sounds. We imagine conversations about new multistory office buildings, mountain vacations, new railroad lines to the suburbs.

The realities of the past have been swept away by time, but the essence of the past is still approachable in old photographs. They are our windows into the past. And what was done, said and written when these photographs were made open these windows for us, just a crack.

Why does the past figure so strongly in Philadelphia? The reason is a little painful to tell. Philadelphia will never retrieve its eighteenth-century glory, when the city had become a learned and political center, the capital of a new nation filled with enlightenment and promise.

William Penn, the converted dissident Quaker from a prominent English family, had not foreseen his "City of Brotherly Love" as the capital of a new world. For Pennsylvania, the vast tract of land received in 1681 from Charles II (repayment of a debt owed to his father), Penn imagined something smaller than a city—"a greene Country Towne." English dominance in the region had been established in 1664, when Sir Robert Carr skirmished with the Dutch on the banks of the lower Delaware River. Peace was the theme when Penn selected the site, a rectangle of 1200 acres between the Delaware and the Schuylkill, not a mile north of a sparse Swedish settlement just a few decades old. The gentle and cooperative natives, the Lenape Indians, who Penn believed were "of the Jewish Race . . . of the stock of the Ten Tribes," only added to his romantic vision of peace and brotherhood. The promise worked: 23 ships with immigrants from London, Bristol and Dublin arrived at the port of Philadelphia during the first year.

Between 1700 and 1800, Philadelphia grew from 4500 residents to more than 81,000. And the straight streets laid out by surveyor Thomas Holme survived, though blocks were cut through with narrow alleys as needed. Here was a growing city, with no end in sight to its burgeoning. Philadelphians who considered growth good fortune were excited.

This good fortune was coming to an end. Beginning with an epidemic of yellow fever that ravaged Philadelphia in 1793, a series of setbacks were at hand. The national capital relocated to the District of Columbia in 1800. New York City soon surpassed Philadelphia in both trade and population. Chestnut Street's temple to finance, the Bank of the United States, closed its doors and capital assets plummeted. By the 1830s, there were race riots in the streets.

Somehow, the enlightened city had degenerated into a barbaric place. When a mob threatened to burn down Pennsylvania Hall—a building dedicated to free speech— even the Mayor sanctioned its destruction. Traumatized and demoralized by repeated blows to its self-esteem, Philadelphia hunkered down as an earnest, modest industrial city that had, long before, been the "Cradle of Liberty." The glorious first century was truly over.

The city continued to expand at an alarming rate, consuming outlying villages with miles of new row houses each decade. (The population had risen to 408,762 in 1850; by 1900 there would be nearly 1,300,000.) At the crowded center, now at Broad and Market Streets, education, religion and entertainment were dispensed from a string of buildings, architectural specimens all. To the Northwest, the huge Fairmount Park was assembled to protect the Schuylkill River water from pollution caused by urban sprawl. Neighborhoods, each with its own ethnic composition and industrial base, grew like satellites around the old, relatively small, center.

Soon Philadelphia forged a new kind of self-esteem, bound to the image of industry. In the beginning of the twentieth century, city boosters told that nearly five million hats and 45 million yards of carpet were produced here every year, that locomotives rolled out of the city's plants at an annual rate of 2600. By 1926, every second of every day in Philadelphia brought another 20 cigars, ten pairs of stockings, a saw and a pair of lace curtains into existence. A new house was completed every nine minutes.

This self-proclaimed "Workshop of the World" lasted briefly. Between the 1920s and the 1980s, 60 percent of the industrial jobs disappeared. Just as the Constitutional City had flourished and faded, this second Philadelphia was also soon gone. In the late twentieth century, Philadelphians live among the ruins of the two great cities. One might consider this a liability, perhaps even a source of embarrassment.

Yet Philadelphia's past has been thought of reverently and fondly. In the 1820s, John Fanning Watson interviewed elderly residents, researched doggedly in old family papers and official records, and wrote an anecdotal *Annals of Philadelphia*. And by the time of the Centennial celebrations for the Declaration of Independence and the Constitution, worship of the past had reached a raging pitch. Philadelphians recently celebrated again with Bicentennials in 1976 and 1987. History, it seems, is the city's best by-product.

If preoccupation with the past is one side of Philadelphia's psyche, the other is surely the city's famous self-deprecation.

W. C. Fields's notorious complaints about his native Philadelphia have ancient roots. Robert Venable, born in 1736, remembered for annalist Watson that Philadelphia was nicknamed "Filthy-dirty" when the city's streets were mostly unpaved. In 1750, Richard Peters wrote to William Penn's son Thomas and complained that the city "will make a most miserable Perspective for want of steeples."

Philadelphia's self-generated image problem persisted. Author Owen Wister called it the "instinct of disparagement." And outsiders never failed to pick up on it. "Philadelphians have grown accustomed to the laugh," wrote Elizabeth Robins Pennell in 1914. According to Mrs. Pennell, her acquaintances from Boston and New York considered Philadelphia the "Road to Yesterday."

Some found Philadelphia's self-effacing habit to be quite tedious and small-minded. They did not understand it. Essayist Christopher Morley did. "The ancient and noble city of Philadelphia," he wrote in 1920,

> is a surprisingly large town at the confluence of the Biddle and Drexel families. It is wholly surrounded by cricket teams, fox hunters, beagle packs, and the Pennsylvania Railroad. It has a very large zoological garden, containing carnivora, herbivora, scrappleivora. . . . The principal manufactures are carpets, life insurance premiums, and souvenirs of Independence Hall. Philadelphia was the first city to foresee the advantages of a Federal constitution and oatmeal as a breakfast food.

G. K. Chesterton experienced in Philadelphia "what many Americans suppose can only be felt in Europe." In *What I Saw In Amerca,* published in 1922, Chesterton wrote of

> that vast grey labyrinth of Philadelphia, [with] great Penn upon his pinnacle like the graven figure of a god who had fashioned a new world. . . . It is at least as possible for a Philadelphian to feel the presence of Penn and Franklin as for an Englishman to see the ghosts of Alfred or Becket. Tradition does not mean a dead town; it does not mean that the living are dead but that the dead are *alive.* It means that it still matters what Penn did two hundred years ago or what Franklin did a hundred years ago; I never could feel in New York that it mattered what anybody did *an hour* ago.

What Chesterton understood as good European civic style, many Philadelphians saw as an American civic sin to be repaid in guilt. It led to admissions: "Philadelphia," said former Governor William Bunn in a turn-of-the-century address, "is rich in her present, but richer in her past." It led to jokes. "Philadelphia is haunted by great men who have been here and gone away," wrote Struthers Burt. And, worst of all, as the job of renovating the city's image fell to those who could not understand why Philadelphians were not more like New Yorkers, it led to full-blown self-condemnation. "Philadelphia isn't as bad as Philadelphians say it is," read a promotional campaign billboard in the 1970s.

Which begs the question: Would Philadelphia be better off without the burden of past greatness? After all, progress is often seen as obstructed by history, particularly in the form of old buildings. Yet history is almost always sacrificed. This book documents the losses: the Slate Roof House in the 1860s, the Graff house in the 1880s, the Art Club in 1975, the gutting of Queen Village for Interstate 95 and the bulldozing of blocks of buildings for Independence Mall.

Conflict with the past continues today: the recent breaking of the "gentleman's agreement" to contain the height of office towers; compromising the United States Naval Home; and continuing debate over the Eastern State Penitentiary. The few notable exceptions (including the metamorphosis of the Lit Brothers building into Mellon Independence Center) would not have occurred had the bottom line not been promising.

Philadelphia Then and Now addresses the issue of a city permanently caught between a valuable past and a promising future. Sixty antique scenes were selected from the Library Company's collection and 60 contemporary photographs were made by Susan Oyama between 1986 and 1988. We begin with a view of Philadelphia from across the Delaware River and move through the oldest neighborhoods along the river and then west along Market Street (pages 2–29). Then we start again near the southern end of Broad Street and move to North Philadelphia (pages 30–51). In the third group, we move up Benjamin Franklin Parkway and into Fairmount Park, out to the Wissahickon Valley (pages 52–75). Next are city institutions, including banks, museums, churches, hospitals and a prison (pages 76–103). The final category features residences, from William Penn's to Edward Stotesbury's and Rittenhouse Square (pages 104–121).

Photographs were not necessarily selected to flatter the city, but to explore the way in which the city has dealt with the past. Philadelphia, it seems, is by turn jealous, proud and ignorant of what it once was. And because this state of mind exists, we are as far away as we ever were from resolving the conflict between then and now.

Philadelphia
THEN AND NOW

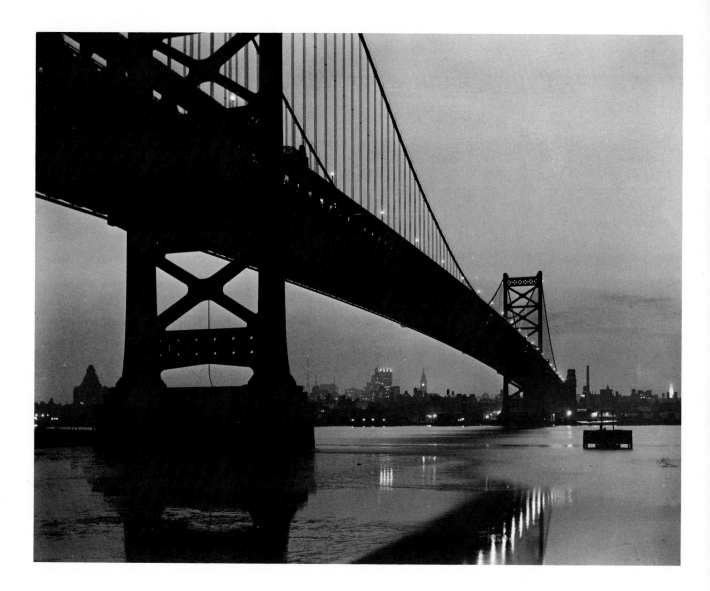

Philadelphia from Camden, New Jersey, ca. 1950

The Delaware River and the Benjamin Franklin Bridge, looking westward to the skyline of Philadelphia
with City Hall (center) and the Philadelphia Saving Fund Society Building.

William Penn's idea for "a greene Country Towne, which will never be burnt, and allways be wholsome" was both a clever advertising concept and an idealistic vision. But the investors and settlers attracted to Philadelphia did not share Penn's vision of a far-flung garden suburb of London. Waterfront landowners cut alleys through their blocks. Squatters refused to move from caves dug into the steep riverbank. Penn's dream that Philadelphia stretch westward to the Schuylkill River conflicted with the reality that this seventeenth-century mercantile village hugged the Delaware River.

Spanning the Delaware at Philadelphia was first seriously proposed in 1818, not long after the bridge upriver at Trenton,

New Jersey, proved an economic boon. Other bridge proposals were considered and rejected in the 1850s and again in the 1870s. Until the Delaware River Bridge and Tunnel Commission was created in 1914, people made do with ferries between Philadelphia and Camden. The idea of a tunnel was rejected, and construction of a bridge was begun. Twelve years and $37,103,765.42 later, the 1.81-mile Delaware River Bridge, designed by Ralph Modjeski, opened as part of the Sesqui-Centennial celebration. On January 17, 1955, the bridge was renamed after Benjamin Franklin to mark the two hundred fif-tieth anniversary of his birth.

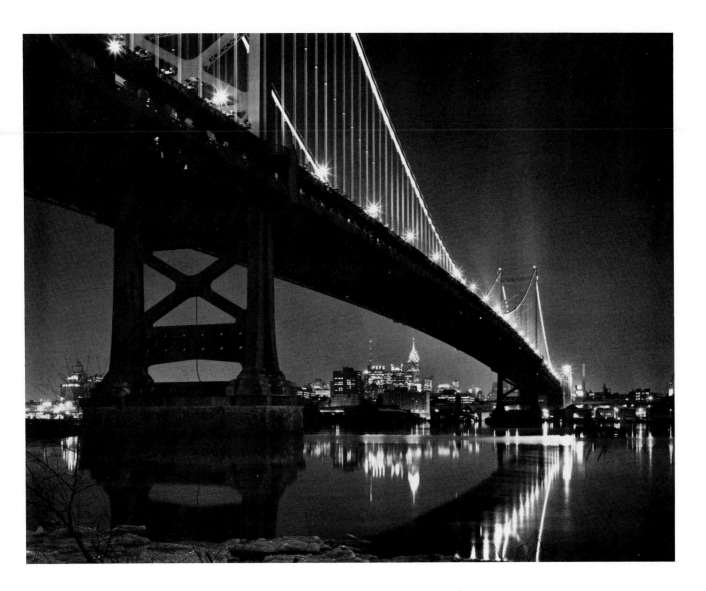

Philadelphia from Camden, New Jersey, 1988

*The Benjamin Franklin Bridge lighted and Philadelphia's skyline with One Liberty Place (center)
—the first building to rise higher than City Hall.*

By the late twentieth century, the "city of firsts" had been transformed into the city of Bicentennials. On September 17, 1987, when the United States celebrated the two hundredth anniversary of the drafting of its Constitution, Philadelphia sponsored back-to-back parades, concerts, feasts and fireworks. And, in a tribute that would last long after the party ended, the Benjamin Franklin Bridge was lit. A design team led by Steven Izenour (of the firm Venturi, Rauch and Scott Brown) installed a series of high-intensity lamps aimed skyward along each of 256 vertical cables. At night, when PATCO trains travel along the bridge, the lights dance like the tapping of ivory notes on a piano keyboard. Guest artists will have their hand at the lighting controls for special occasions. "Make that bridge rock 'n' roll," a newspaper editorial commanded.

Industrial Philadelphia continues to leave its watery roots. The port now handles more tonnage, but less profitably, and developers prefer to attract tourists, not tugboats. The shift from industrialization to gentrification is under way. Commercial piers are recast as residential units with marinas. Penn's Landing regularly accommodates tens of thousands for the Jambalaya Jam, Rockarama and other weekend extravaganzas with pralines, ducktail displays and Elvis look-alikes. The old commercial city has waned; the new one rises with a billion-dollar waterfront development. Philadelphia has shed its sleepy look.

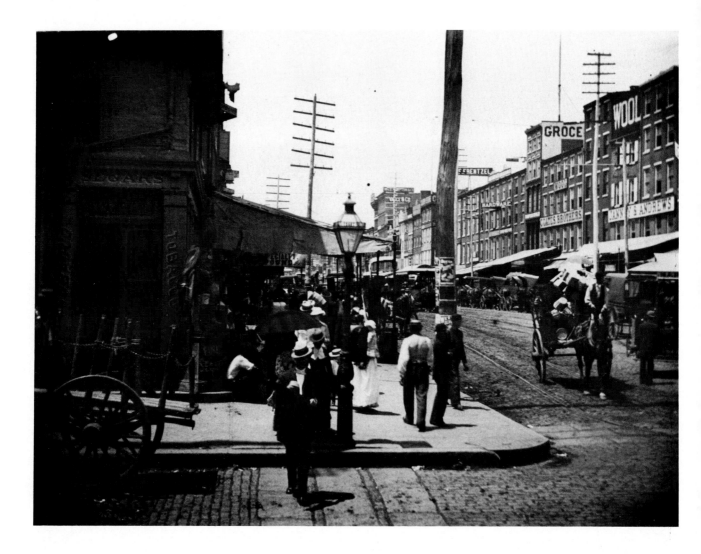

"Looking up Market Street from Front," July 1882

*Commercial lower Market Street, near the Delaware waterfront just west of the
trolley turnaround and the ferry dock.*

As the city's first commercial center, lower Market Street bustled with commerce and trade. During the city's first 180 years, open markets ran up the middle of High (later Market) Street. Hucksters cried their "fruits and vegetables . . . the grateful musk-melon, sweet potatoe, cucumbers and peaches, immense quantities of which are brought in boats across the Delaware," wrote James Mease in 1811. The brick piers and vaulted ceilings of these markets were replaced in the 1830s with spindly cast-iron supports and umbrellalike tin roofs. And in another 30 years, the railroad companies decided to run railroads up the center of the street. The market lost its right-of-way.

In spite of these busy changes, people remembered the eighteenth-century publishing and intellectual center that emanated from the Old London Coffee House at Front and Market. Near Second Street was Franklin's printing shop. Robert Bell's (where Thomas Paine's *Common Sense* was printed), John Dunlap's (where the Declaration of Independence was issued) and Robert Aitken's (where the first English Bible in North America was printed) were all within a few blocks.

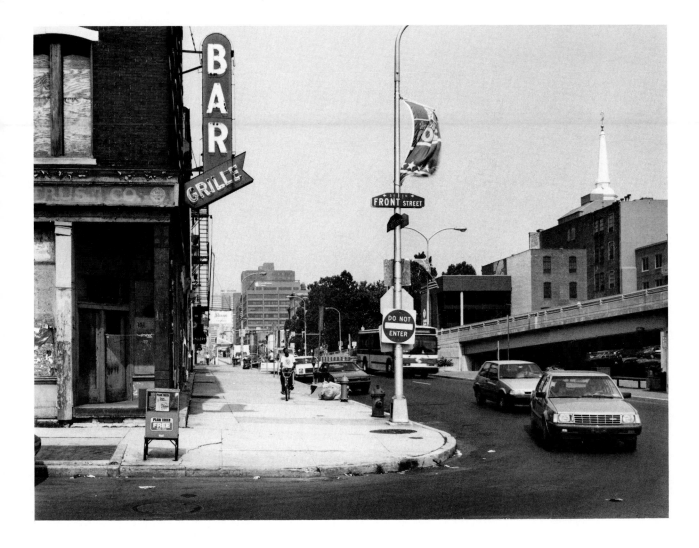

Looking up Market Street from Front, 1987

Lower Market Street after commerce and transportation moved westward, beyond Society Hill and the Independence Hall area. On the right is a turnaround ramp and Christ Church tower.

As long as the ferry was the only way from Philadelphia to New Jersey, lower Market Street remained a hub of activity. Walt Whitman was often among those who transferred from horsecar to steamer there. He delighted in the waterfront's broad waiting room. One afternoon, after a matinee, he wrote:

> I never knew the spacious room to present a gayer, more lively scene—handsome, well-drest Jersey women and girls, scores of them, streaming in for nearly an hour—the bright eyes and glowing faces, coming in from the air—a sprinkling of snow on bonnets or dresses as they enter—the five or ten minutes' waiting—the chatting

and laughing. . . . Towards six o'clock the human stream gradually thickening—now a pressure of vehicles, drays, piled railroad crates—now a drove of cattle, making quite an excitement, the drovers with heavy sticks, belaboring the steaming sides of the frighten'd brutes.

Ferry traffic increased to 5.5 million passengers in 1925. But when the bridge opened a year later, lower Market Street began to lose its importance for the first time since the founding of Philadelphia. The Philadelphia and Camden Ferry Company made its final crossing in 1950.

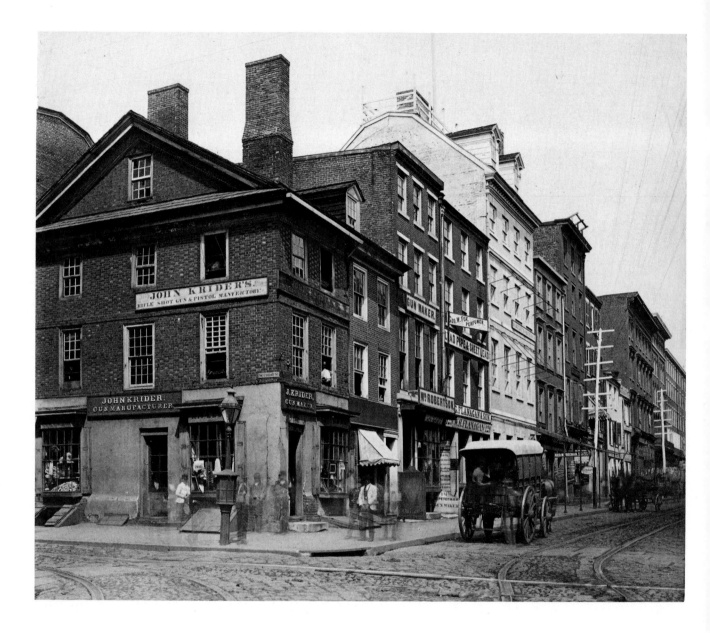

Northeast Corner, Walnut Street at Second Street, ca. 1867

John Drinker's house (1751) occupied by John Krider's Gun Shop.

In an attempt to make conversation with Benjamin Franklin, Louis XVI inquired as to the longevity of Americans. "I can better answer your Majesty's question when old Drinker dies," Franklin quipped. He referred to John Edward Drinker, born on Christmas Eve 1680, in a cabin located at what would become the northeast corner of Second and Walnut Streets. The "first native Philadel- phian," as Drinker became known, rebuilt his house in 1751 and lived there until he was nearly 102. Toward the end of his life, Drinker would point out sites where Indians camped and Swedes built. And he told of being taken, as a toddler, to witness the arrival of William Penn. In the nineteenth century, John Krider turned the Drinker house into a renowned gun shop.

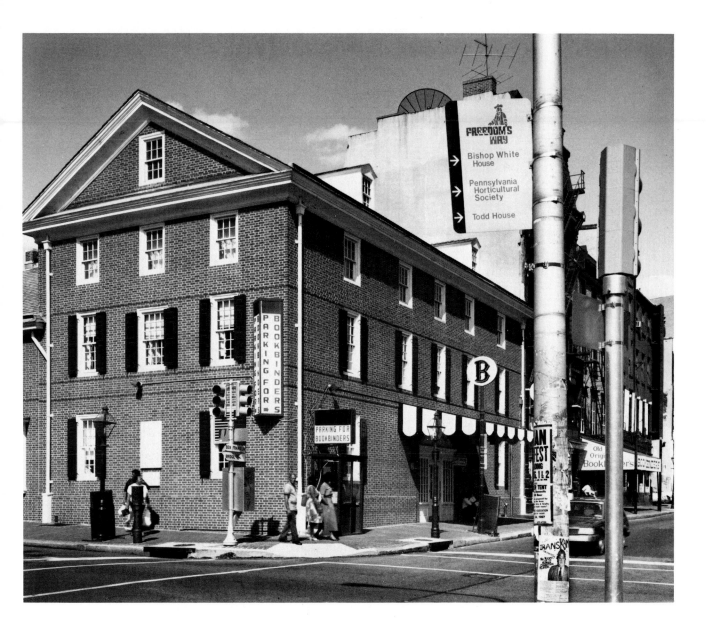

Northeast Corner, Walnut Street at Second Street, 1987

The Old Original Bookbinder's Seafood Restaurant.

In the twentieth century, at the behest of the adjacent Bookbinder's Restaurant, the city condemned the Drinker-Krider building as unsafe and permitted its demolition. Grant Miles Simon, chairman of the Philadelphia Historical Commission and an architect, designed a "meticulous copy" of the Drinker-Krider house to become the restaurant's "Hall of Patriots" banquet room and "Signers" dining room. On December 20, 1960, Mayor Richardson Dilworth, Mrs. Bookbinder and another official used a three-handled shovel to break ground for the new wing.

As a reconstruction, the building's proportions were interpreted freely, the brick color was inaccurate and the roof had the wrong pitch. But this was the first private effort in the redevelopment of Society Hill. Archaeological and architectural correctness would have to wait. The restaurant capitalized on its old Philadelphia location, though Colonial associations alone did not attract the dining public. Rather, Bookbinder's became famous for the more recent figures who dined there: Diamond Jim Brady, Enrico Caruso, Alfred Hitchcock and John Wayne.

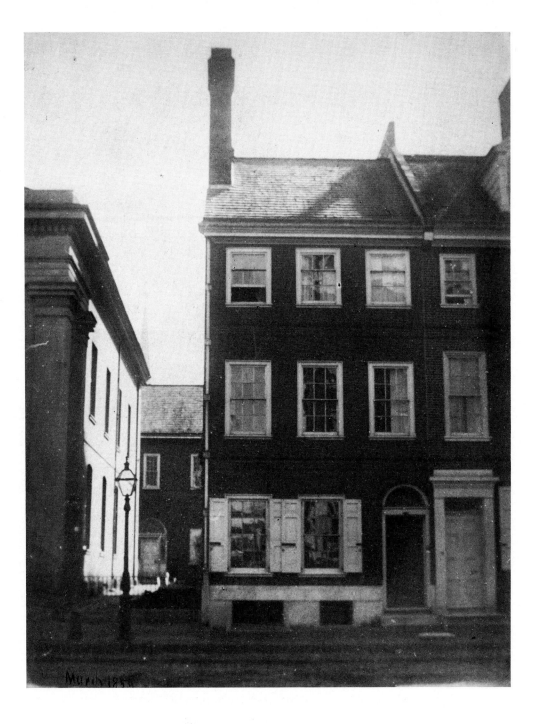

322 Spruce Street, 1859

Where Reverend William Marshall was host to Louis-Philippe.

Nineteenth-century historians collected photographs of eighteenth-century houses that had stories to tell. The Reverend William Marshall's house at 322 Spruce Street had one worth telling. In 1796, the Marshall family was host to Louis-Philippe, the Frenchman who was to be king. Louis-Philippe was forced to put his own ambitions aside and leave France in order to secure the release of his imprisoned family. He set sail for Philadelphia and, until his brothers joined him the following year, he was a guest of the Marshalls on Spruce Street. When the danger appeared to be over in 1800, he returned to Paris only to find Napoleon firmly in command. More patience and endurance were required. Louis-Philippe was forced to leave again, this time for England and then Sicily.

When Napoleon fell, Louis-Philippe returned to France. During the Revolution of 1830, he wrapped himself in a tricolored scarf and walked to the headquarters of the Republican Party, where Lafayette waited. There, for all to see, Lafayette embraced Louis-Philippe and proclaimed him "king of the French, by the grace of god and the will of the people." He was known as "the citizen king."

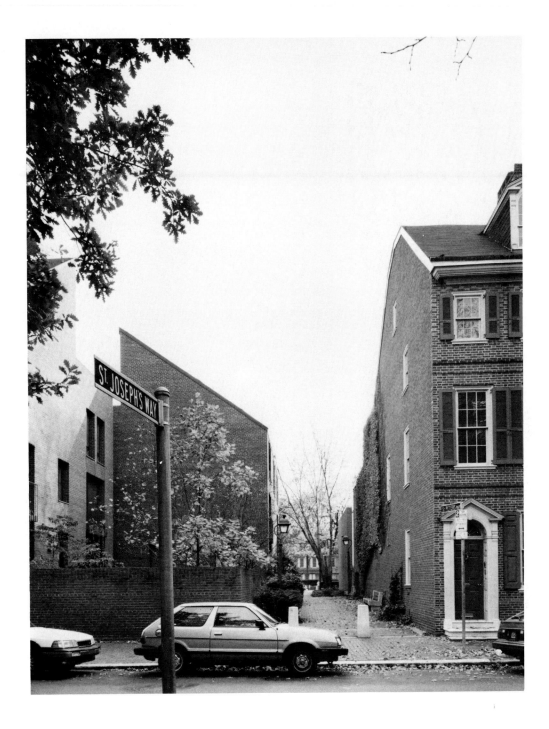

Spruce Street at Saints Joseph's and Peter's Way, 1987

A view of a part of the Greenway System toward Three Bears Park.

As long as the Marshall house stood, the story of Louis-Philippe was told and retold. But as soon as it was demolished, the story was deprived of its immediacy and dropped from popular culture. But in Society Hill, every house has a story. To the west, at No. 324, lived Samuel Clarkson, midshipman on the *Empress of China,* the first American ship to reach China (1784).

In the mid-1940s, architect Roy Larson proposed a network of quiet, richly planted footpaths to link the Independence National Historical Park to Society Hill's other historic buildings. The spire of Saint Peter's Church (Third and Pine Streets) was made the visual focus and destination of one of these paths in the so-called Greenway System. Halfway to Pine Street, this particular path opens onto Three Bears Park, a playground named after a sculpture there. Edmund N. Bacon continued to develop this network of picturesque paths and parks while heading the Philadelphia Planning Commission in the 1950s and 1960s.

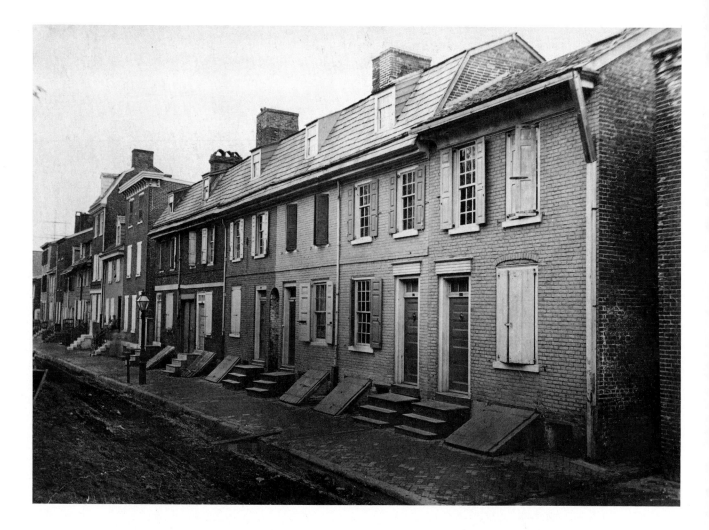

Queen Street, between Swanson and Front Streets, 1867

English-style speculators' houses, ca. 1740.

When he visited Philadelphia, Thomas Penn liked his walk south to rural Wicacco. He was not the only one. Wicacco meant "pleasant place" to the native Indians. And the sauna-taking, fur-trading Swedish settlers had made it their home, beginning in 1709. Only a few English speculators were beginning to cut new streets there and line them with common brick houses. The city's oldest structure, Sven Swanson's log house, still stood on the rise near Swanson and Beck Streets.

By the 1740s, English speculators had taken over Wicacco. Penn's secretary (who wrote in the polite third person) warned that "Southwark is getting greatly disfigured by erecting irregular and mean houses, thereby so marring its beauty that, when he shall return, he will lose his pretty walk to Wicacco." British soldiers claimed Swanson's house for firewood during a cold winter in the Revolution, and people soon forgot that it ever existed. In 1867, John Moran visited the neighborhood to photograph what was left and made an admiring view of a row of the very urban sprawl that Penn was warned about. Over time the houses had grown picturesque.

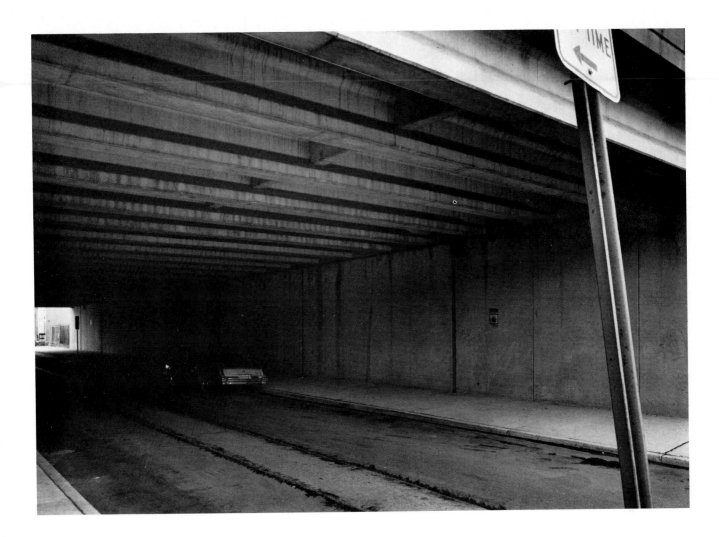

Queen Street, between Swanson and Front Streets, 1987

The underside of Interstate 95.

When the construction of the Delaware Expressway, Interstate 95, became a certainty in the 1960s, Philadelphia's oldest and best-preserved neighborhood—Queen Village—prepared for the worst. Architectural historians documented the most significant buildings in drawings and photographs. In 1967, 130 historic structures were demolished. The remaining neighbors of Queen Village organized to resist the construction of access ramps, to prevent further destruction of their neighborhood.

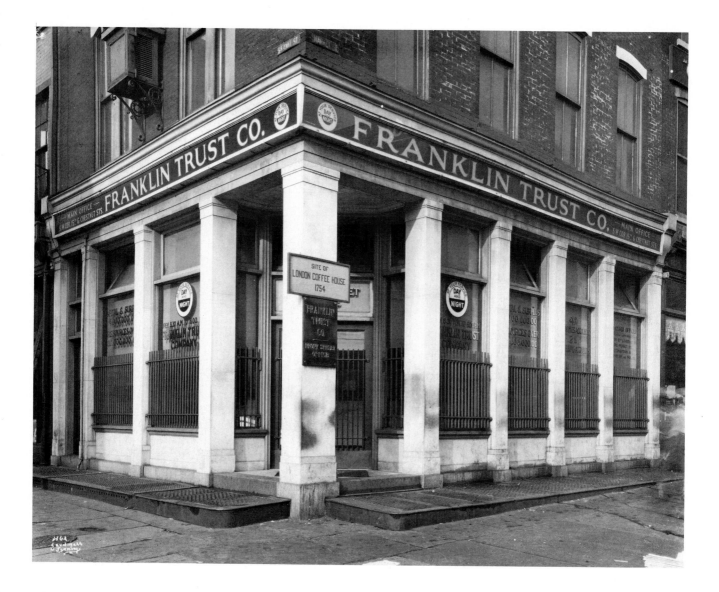

Southwest Corner of Front and Market Streets, ca. 1925

Site of the London Coffee House, a gathering place in the eighteenth century.

George and Albert Ulrich, who bought the London Coffee House in the late nineteenth century, must have been charmed by its historical associations, but the aroma of coffee and the headiness of politics were soon forgotten. The printers and merchants who had once gathered there were long gone. Gone, too, were the fishermen who celebrated May Day and the slaves once sold by its door. The Ulrichs, who made and sold cigars, had purchased the old London Coffee House for its capacity, not for its character.

As newer and taller buildings replaced its neighbors, the steep hipped roofs of 1702 began to look particularly out-of-date. No. 100 Market Street was an up-and-coming commercial address, so the Ulrichs demolished the London Coffee House, replacing it with a five-story building. All that remained of the old address was a painted plaque, mounted by the historically minded near the door of the new building.

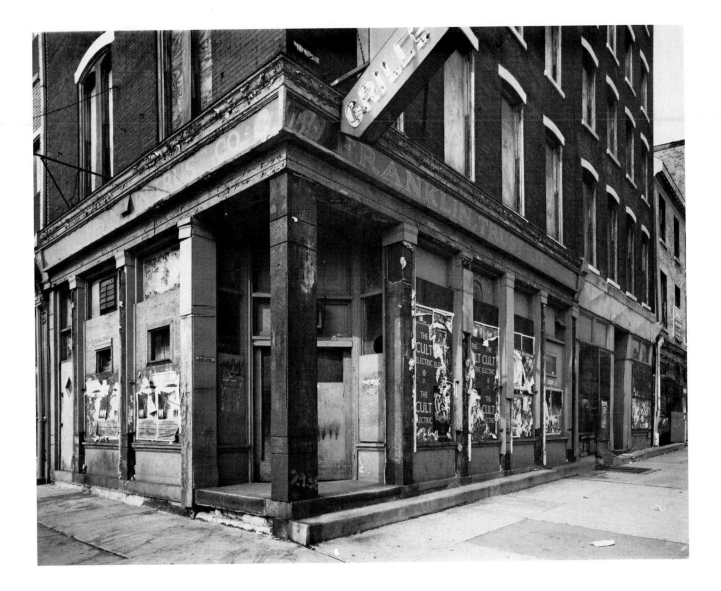

Southwest Corner of Front and Market Streets, 1987

Site of the Franklin Trust Company.

The Franklin Trust Company acquired the building. At least the name provided some continuity with the past.

In 1890, 100 years after his death, there was a spree of Franklin namings. The Franklin Sugar Refinery and the Franklin Reformatory for Inebriates were soon joined by the Franklin Biscuit Company, the Franklin Portable Crane and Hoist Company, the Franklin Button Works and the Franklin Odorless Excavating Company. In another ten years there were the Franklin Dye Works, the Franklin Flint Glass Works, the Franklin Fountain Pen Company, the Franklin Hosiery Company, the Franklin Paper Bag Company, the Franklin Steam Laundry and the Franklin Trust Company, whose Front Street Office posted convenient hours. After a while, the plaque was gone, the bank was closed and a grill operated on the first floor. After a while longer, that too was closed.

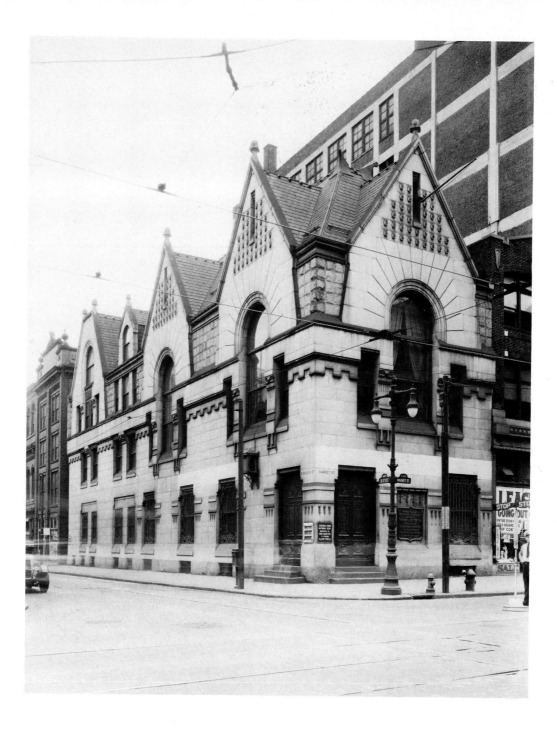

Seventh and Market Streets, ca. 1935

The site where Thomas Jefferson drafted the Declaration of Independence,
occupied by architect Frank Furness' Penn National Bank.

There had been some debate as to where Jefferson resided. Over the years, several houses in the vicinity of Seventh and Market Streets sported banners and signs, each claiming to be the true "Birthplace of Liberty." Finally, James Mease, a stickler for historical fact, obtained clarification from the aged Jefferson, then residing at Monticello. "At the time of writing that instrument I was lodged in the house of a Mr. Gratz [Graff], a new brick house, three stories high, of which I rented the second floor . . . ," wrote Jefferson. "In that parlor I wrote habitually, and in it wrote that paper particularly."

The old brick house had survived on this site about a century. In 1883, the Penn National Bank building went up in its place. Architect Frank Furness gave its replacement historical references: huge Palladian windows and steep roofs, eclectic features that abstractly informed Victorians that something special was at hand. Furness also added a plaque, a bronze billboard, next to the entrance. "On this site," it read in part, "originally stood the dwelling in which Thomas Jefferson drafted the Declaration of Independence." The old brick house was remembered.

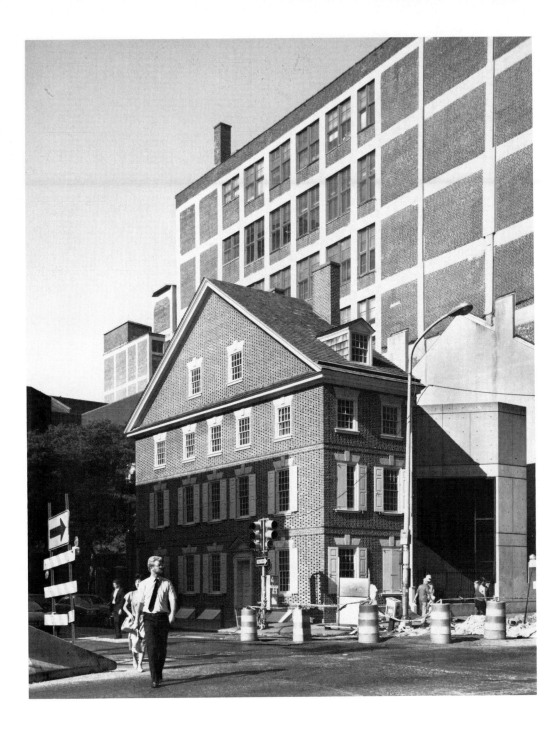

Seventh and Market Streets, 1987

*The site where Thomas Jefferson drafted the Declaration of Independence,
occupied by a reconstruction of the original Graff House.*

During the Depression, the Furness bank was demolished and replaced by Sam Besses' Tom Thumb luncheonette. But many of the customers of hot dogs, fish cakes and milk shakes remembered the Jefferson connection. Even the Congressional National Shrines Commission visited the site in 1947. As the Bicentennial of the Declaration approached, the idea of reconstruction gained support among politicians, though not among historians ("Spurious bits of historical stage scenery," wrote George Tatum). But the Convention and Tourist Bureau wanted the Graff House back. In 1968, $2 million was set aside to rebuild it.

15

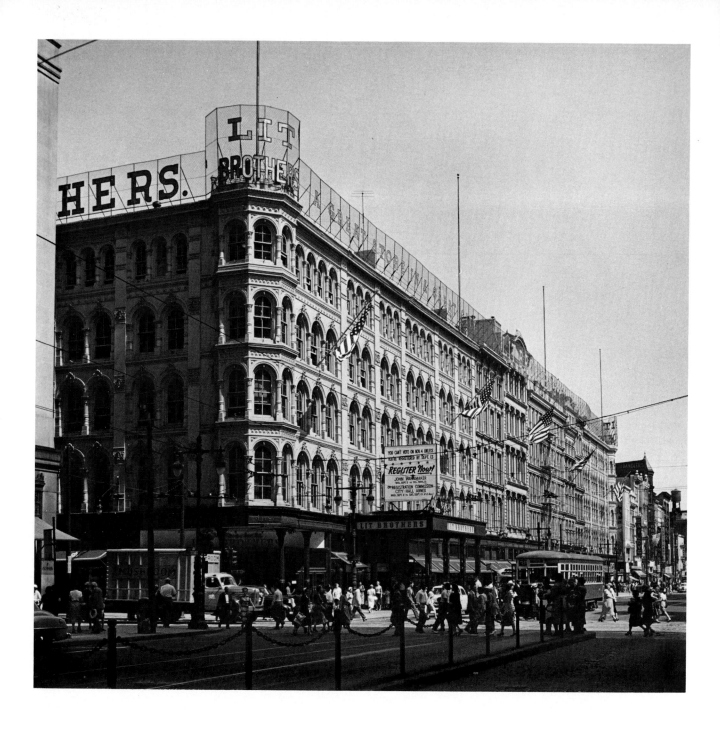

Lit Brothers, Eighth and Market Streets, ca. 1952

*Department store where "hats [were] trimmed free of charge" in a block-long
group of buildings tied together behind a cast-iron facade.*

John Wanamaker proudly admitted that he made his department store great through advertising. He even published full-page advertisements to show his store's floor plans so that customers might save time finding the desired counter. Naturally, the Wanamaker account was the plum of the city's newspaper publishers. But in 1901, when *The Philadelphia Record* increased the annual advertising rate from $87,500 to $112,500, Wanamaker hesitated. The *Record* turned to the Samuel and Jacob Lit department store, which instantly agreed to pay the price for the coveted Wanamaker pages.

Only 11 years earlier, the Lit brothers had joined their sister

Rachel in her dress shop. The business had grown to occupy the entire block between Seventh and Eighth Streets, including 15 miscellaneous commercial buildings with cast-iron and terra-cotta facades. Not long after the Lit brothers signed with *The Philadelphia Record,* they hired architects Collins and Autenrieth to tie the buildings together into a single store. Meanwhile, five blocks to the west, John Wanamaker was creating a place where Old Philadelphians would shop. He demolished his converted train depot and imported prestigious Chicago architect Daniel H. Burnham to build a Renaissance Revival palace of consumerism.

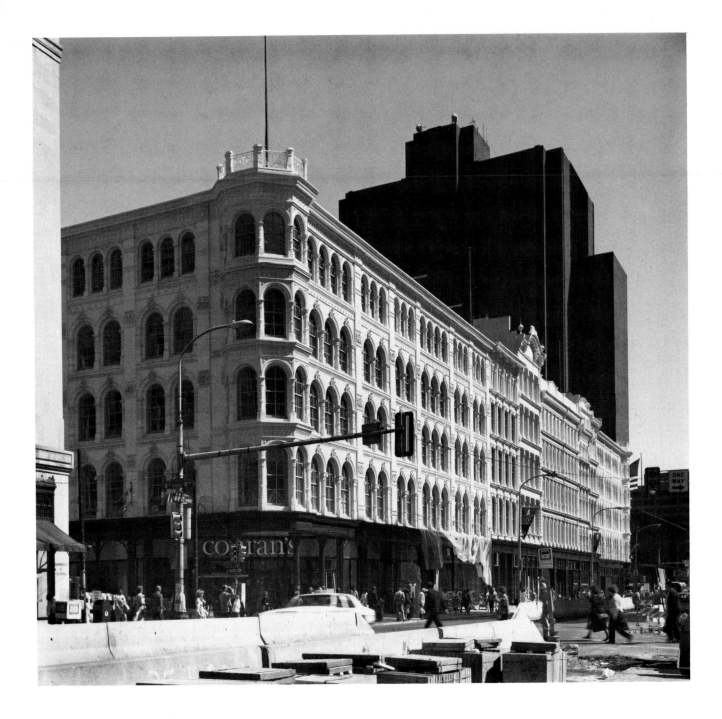

Mellon Independence Center, Eighth and Market Streets, 1987

The most significant Center City building saved from the brink of demolition in the 1980s.

Lit's thrived, too, even when Market Street was virtually lined with department stores: Gimbel Brothers, Strawbridge and Clothier, Frank and Seder, Snellenberg's and Wanamaker's. But the twentieth century was especially hard on Market Street. Shoppers turned to the new suburban malls and, one by one, the Center City department stores began to go out of business. Lit's closed in 1977, and a few years later demolition seemed imminent. Hundreds of preservationists protested. "Let Lit's Live" was their motto (and the name of their coalition). Victory seemed at hand in February 1984, when a developer agreed to preserve the facade. But two months later, demolition seemed to be the only choice that offered profit. Exercising its authority, the city's Historical Commission postponed demolition, but when a disastrous fire in a nearby building made Fire Department officials very much inclined to support demolition, the Historical Commission relented. "Demolition Expected to Start Soon," read a headline. It did not. Another developer took over and constructed office space at a cost comparable to that of new office towers. In October 1987, after a $90-million renovation, Lit's was rededicated as Mellon Independence Center, an office building with shops at ground level.

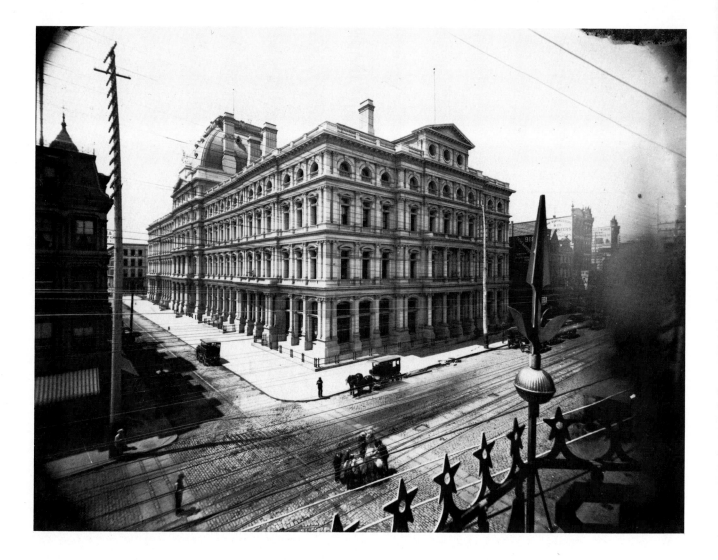

Post Office, from Gould's Furniture Store,
Southwest Corner of Ninth and Market Streets, ca. 1895

*Site of the first White House, the second location of the University of Pennsylvania and
Philadelphia's twenty-third Post Office.*

What Philadelphia's twenty-second post office lacked in scale it made up in charm. The Civil War postal palace near Fifth and Chestnut Streets was marble-veneered and quaint, but obsolescence came within only a decade. Meanwhile, the University of Pennsylvania vacated this commodious site on Ninth and Market Streets (see page 84) and a new kind of postal palace was begun, in the Victorian-Federal style, inspired by the Paris of Napoleon III. Architect Alfred B. Mullett also left his mark on Boston, St. Louis, New York, Chicago, Portland, Madison and San Francisco.

John McArthur, Jr. supervised the project during the 11 years of its construction, beginning in 1873. McArthur must have appreciated the way Mullett's mansard roof was enlivened by Daniel Chester French's sculpture *Law, Prosperity and Power.* At City Hall, McArthur's own concurrent project further west on Market Street, he enjoined sculptor Alexander Milne Calder to explore and expand the relationship between architecture and sculpture. If French's sculpture on the post office whispered a melody, Calder's sculpture on City Hall reverberates an opera.

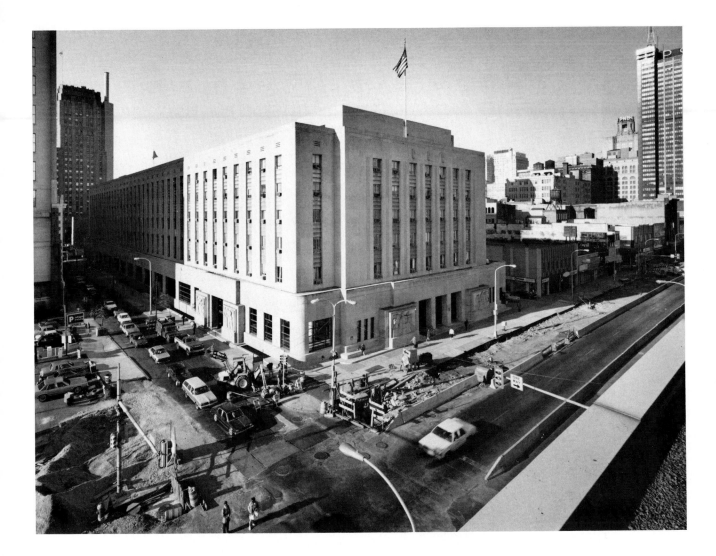

Post Office and Court House, from the Gallery,
Southwest Corner of Ninth and Market Streets, 1987

Philadelphia's twenty-fourth Post Office.

By the mid-1930s, tastes in architecture had cooled from a controlled pomp to an austere detachment. The only thing warm about H. Sternfeld's Mussolini Modern post office and courthouse was its limestone. Mullett's building went quietly, as did so many of the nineteenth-century masterpieces. *Law, Prosperity and Power* was saved, and placed alone on the windy top of George's Hill in Fairmount Park.

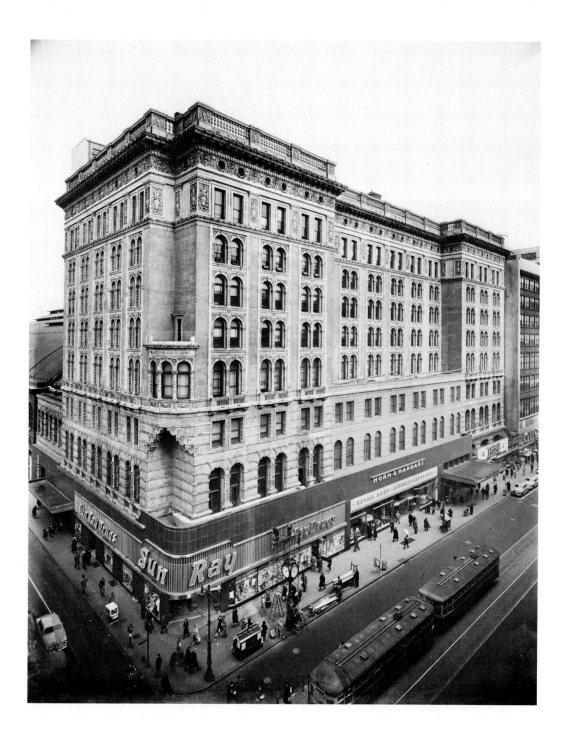

Reading Terminal, Northeast Corner of Twelfth and Market Streets, ca. 1950

Headhouse, shed and market of the Reading Railroad (successor to the Philadelphia, Germantown & Norristown Railway, incorporated in 1831).

The Reading Railroad had a few ups and many downs in the late nineteenth century. Philadelphians winced at the thought of Reading's bankruptcy in the 1880s and its purchase by New Yorkers. In 1891, Francis Harry Kimball designed a broad, severe palace with pink brick walls, terra-cotta trim and a copper cornice. One architectural historian likened it to "a wide, level cliff with a cave at its base." The 45,000 passengers who passed through daily did not cozy up to the Reading Company as they did to the Pennsylvania Railroad.

Reading passengers did, however, develop loyalties to the market beneath the train shed. Here was a symbiotic and successful arrangement. Reading officials never took into account that the way to Philadelphia's heart was through its stomach. But in 1931 President Agnew T. Dice did wax eloquent, not about his two-tone green locomotives but about the "green goods from Mexico . . . deer meat from the Arctic, nuts from Africa, dairy products and delicacies from Europe, . . . fruits from the Argentine and Brazil . . . Florida and California," all purveyed by the railroad market's many aproned tenants.

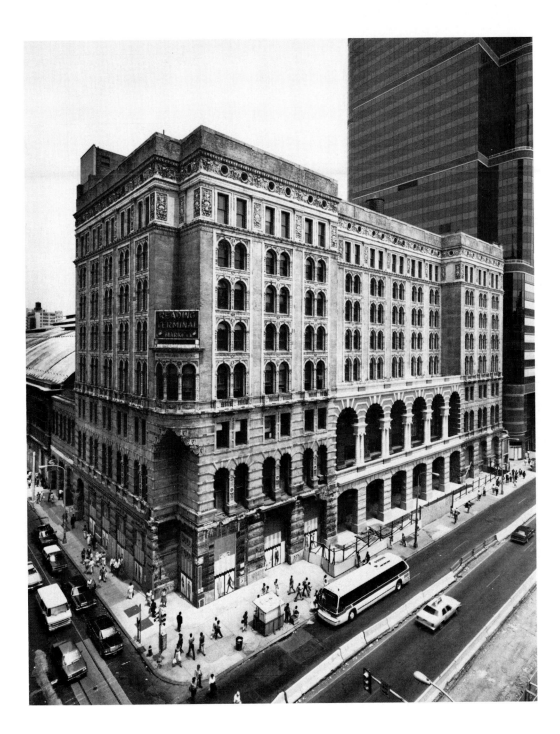

Reading Terminal, Northeast Corner of Twelfth and Market Streets, 1987

*Proposed convention-center site with the 95-year-old Reading Terminal Market
beneath the empty landmark shed.*

The train shed built by the Wilson Brothers for the Reading Railroad, which for a brief moment was the largest shed in the world, joined the National Register of Historic Places in 1972. Twelve short years later, there was a sad, celebratory evening populated by railroad fanatics wearing souvenir T-shirts and badges. A Depression-era "Blueliner," the last train to depart Reading Terminal, left for Lansdale. The long escalators inside the diesel-smelling Market Street entrance stopped the next day. The $300-million commuter rail tunnel was finished, and the Reading Company quietly redirected its efforts to real-estate development with the single-minded goal of a massive new Convention Center

at Twelfth and Market. The cost was first estimated at $283 million, then $468 million, then as high as $600 million.

Meanwhile, the Reading Market beneath the train shed bid farewell to the days of empty booths and losing money. With new and careful management and an increasingly food-conscious city, the market gained purveyors to fill its aisles. By the mid-1980s, 400 workers sold 75,000 weekly customers some $20 million worth of oysters and ice cream, bratwurst and Amish baked goods. The once-familiar rumble of trains overhead will be replaced by the din of new construction, if a proposed convention center is begun.

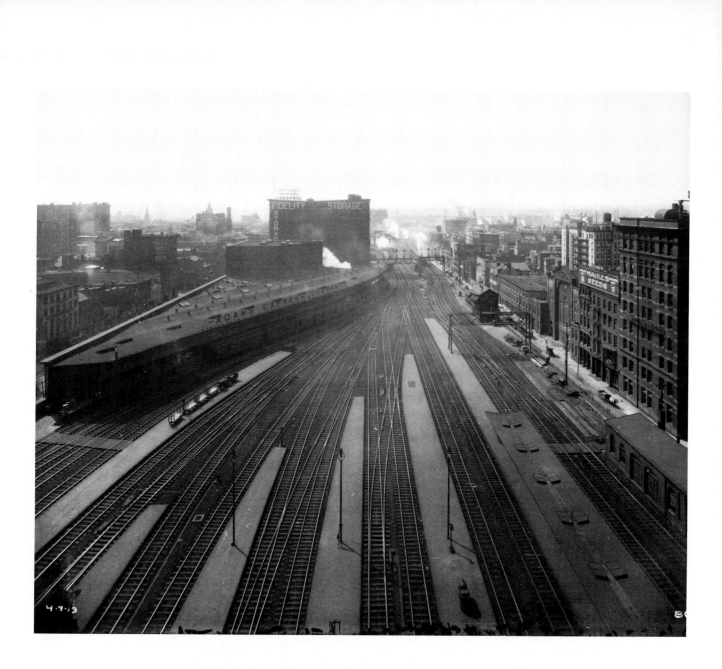

Pennsylvania Railroad Viaduct (the Chinese Wall), from the Station Shed, Looking West, 1913

Behind Broad Street Station. Filbert Street (right); Market Street (left).

For nearly three decades Philadelphians tolerated railroads running down the center of Market Street. To alleviate increasing congestion and danger, an elevated platform extending from West Philadelphia into the center of town was proposed in 1879. The Wilson Brothers were hired to design this 2042-foot raised roadbed as well as the station at its terminus. The construction of 48 brownstone-faced brick arches of the viaduct—the Chinese Wall—was complete in less than a year and a half.

Locomotives came and went in such numbers that the station had to be enlarged in the 1890s. And, on that occasion, the Pennsylvania Railroad took the opportunity to one-up the Reading Railroad. Pennsy built a shed 306 feet wide, breaking the world record previously set by the Reading Terminal at Twelfth and Market Streets.

The public regarded the Chinese Wall as a symbol of progress, though it was disconcerting to railroad executives. A more perfect bottleneck for trains coming in and going out of the city could not have been designed. Because of intolerable schedule disruptions, passengers soon embarked for Washington, New York or Chicago, not from Center City, but from stations in West or North Philadelphia. A fire at Broad Street Station in 1923 advanced thoughts that the company should demolish the station and replace its great swath of real estate with a new "Pennsylvania Boulevard," lined with tall office buildings. The only impediment to this new project was its $60-million projected cost.

Southwest Corner of Sixteenth Street and John F. Kennedy Boulevard, 1987

Reliance Building, Four Penn Center Plaza, across from One Penn Center at Suburban Station (right).

"The status symbol among U.S. cities these days is the bombed-out look," wrote *Time* magazine's Gurney Breckenfeld late in 1964.

> Every self-respecting city seems to want to be hideous with rubble and raw earth, crawling with helmeted workers, snorting earth-movers and angular cranes. These are the signs and portents of the biggest civic building boom the U.S.—or any other country—has known. It goes by the name of urban renewal, but it might also be called emergency surgery.

Philadelphia was ahead of the trend. The same week that Breckenfeld's article appeared, Penn Center's first buildings were completed—three boxy International Style towers with alternating bands of limestone and windows. In fact, Philadelphia Planning Commission's Edmund N. Bacon earned the cover portrait on *Time*, which declared: "Of all the cities under the planner's knife, none has been so deeply and continuously committed to renewing itself as . . . Philadelphia." More than $2 billion of federal, state, municipal and private funds had been applied in the previous dozen years, according to *Time*, in "the most thoughtfully planned, thoroughly rounded, skillfully co-ordinated of all the big-city programs in the U.S."

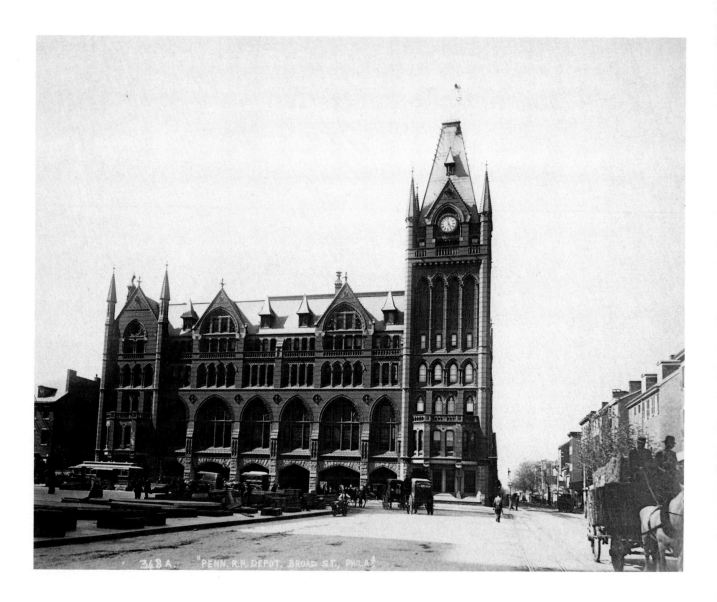

Broad Street Station, Southwest Corner of Broad and Filbert Streets, ca. 1890

Pennsylvania Railroad terminal headhouse.

When late nineteenth-century Philadelphians spoke of the president, they usually meant the chief executive officer of the Pennsylvania Railroad. And where better than Broad and Market Streets, the actual and symbolic center of the city, for its headquarters? As the Pennsy built its own system and consolidated many of America's haphazard rail lines, Philadelphians developed the notion that the industrialized world emanated from their city in general, and Broad and Market in particular. One finger of this system extended to the north and elegantly terminated at Pennsylvania Station in the center of Manhattan.

Broad Street Station demonstrated that the Pennsylvania Railroad had become expert at public relations in the guise of city planning. Architects orchestrated the way in which the public would come to know the company. They set the new station at a corner of the impressive plaza northwest of City Hall. Lessons in history, sculpted on its facade, mirrored one of City Hall's own themes: Technology is progress. Inside, the public was conducted through a series of grand interior spaces before the consummate encounter with the locomotive—the steam-breathing symbol of progress—at rest in its lofty iron shed.

The site seemed perfect. As Masonic Hall at Broad and Filbert topped out and City Hall took form behind its web of scaffolding, the city's various other institutions had congregated along Broad Street. The heart of the city had defined itself as its founder had intended: Center Square—Penn Square—had become the center of town.

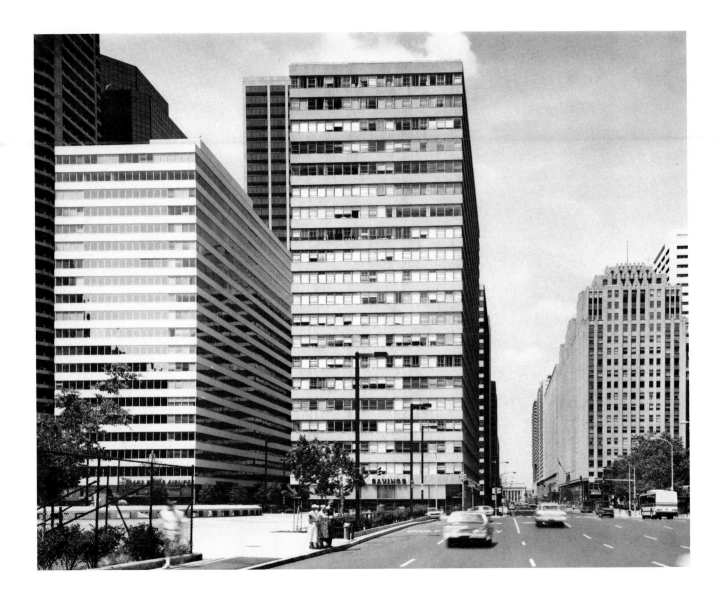

Southwest Corner of Fifteenth Street and John F. Kennedy Boulevard, 1986

Penn Center (left) and Suburban Station (right).

Broad Street Station, however, was obsolete before it had opened in 1882. Constantly building and merging, the company had grown faster than its own management had anticipated. Even after an expansion in the early 1890s, the overcrowded station plagued its managers. One troubling, unavoidable problem was that trains entered and exited from West Philadelphia by backing into town on the Chinese Wall.

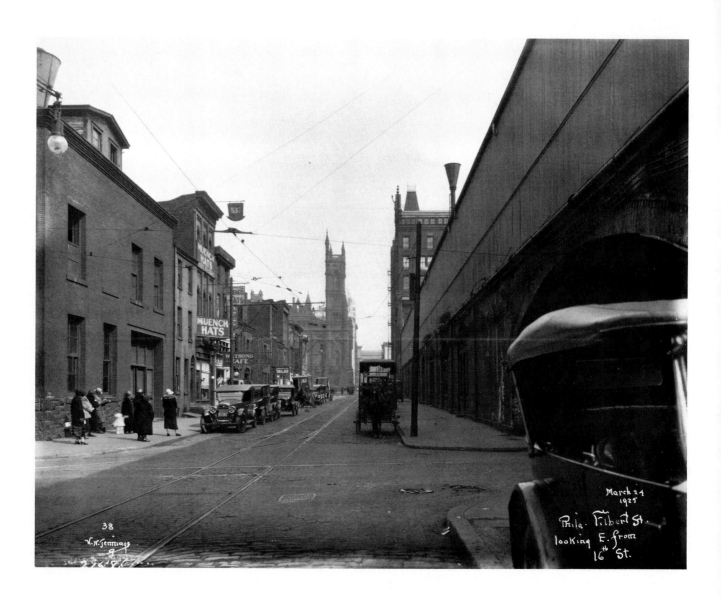

Filbert Street, Looking East from Sixteenth, March 24, 1925

Alongside the Broad Street Station and the Chinese Wall, toward Broad Street and the Masonic Temple.

The Chinese Wall was a formidable neighbor for over 70 years. Cinders rained from it; those who passed through its 55-foot-wide tunnels spanning the north–south streets endured the dark stalactites dripping from its arched ceilings. When it was demolished in the 1950s, the way from Penn Center was cleared, but Penn Center only stretched to Eighteenth Street. Center City went no farther west.

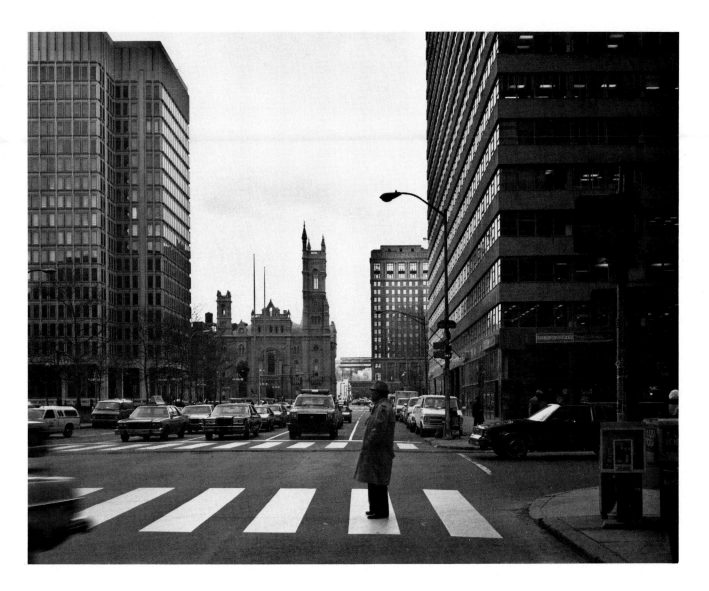

John F. Kennedy Boulevard, Looking East from Sixteenth Street, 1987

*Alongside Penn Center (right). The Municipal Services Building (left), Masonic Temple (middle, left)
and City Hall Annex (middle, right).*

In 1925, Pennsy announced its intention to demolish Broad Street Station and build a row of tightly packed modern office buildings in its place. But the Depression cut short the building boom and the plans were shelved. Twenty-seven years later, when the company announced the demise of the station and the Chinese Wall, city planner Edmund N. Bacon unveiled a model for three office buildings with abundant plazas and sunken gardens. The open space would be light because the buildings would have a north–south orientation. Even the shopping concourse below would catch the sun's rays.

The idea of Penn Center had occurred to Bacon years before.

With architect Vincent Kling, he had prepared models and drawings and was ready when the railroad announced its plans to demolish the station. Bacon's inner-city esplanade was truly visionary for America of the 1950s. Old industrial cities were not adding to their stock of buildings, yet Philadelphia was calling attention to itself with a large development where a full 70 percent of the site would be open public space. If built as conceived, Bacon's plan would have been downright philanthropic. But the original design was compromised with enlarged buildings set on an east–west axis. Unlike the railroad, which became more grand with time, Penn Center grew less so.

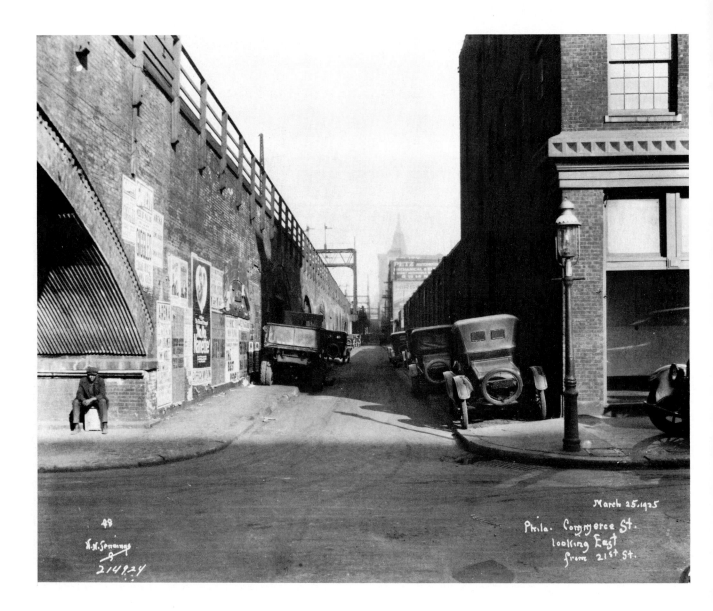

March 25.1925

*Phila. Commerce St.
looking East
from 21st St.*

Commerce Street, Looking East from Twenty-First Street, 1925

The Chinese Wall between Eighteenth and Twenty-First Streets before approaching the Schuylkill River;
City Hall tower (center).

The western portion of Center City, always industrial with coal docks, stoneyards, lumberyards and the gasworks, became a haven for automotive shops in the early twentieth century. In time, this peripheral area was consumed by growth.

Prestigious offices eventually located west of Broad Street, stretching the boundary of Center City to the Schuylkill River. The spearhead in this westward movement was Market Street and Kennedy Boulevard. And on its new, broad, block-long lots, a string of tall and bland office buildings and hotels were built from where Penn Center left off. This stretch became a canyonlike continuation of Penn Center, where pedestrians were cooled in shadows and buffeted by winds.

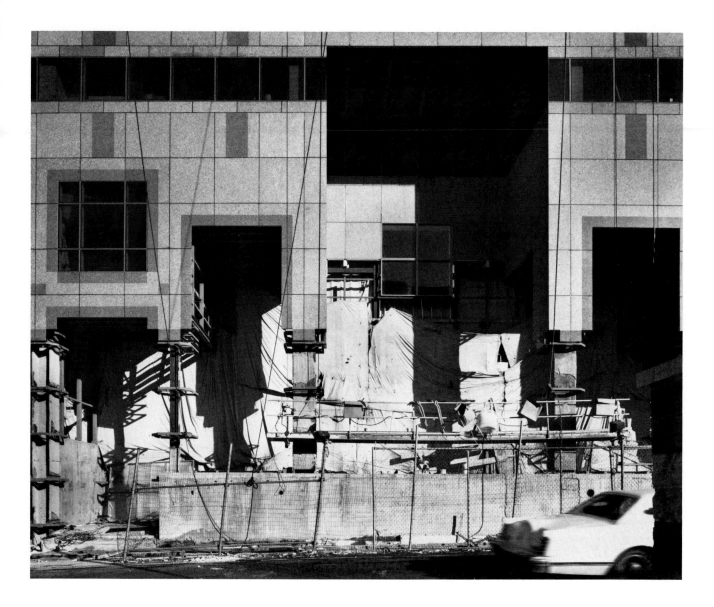

Commerce Square, North of Market Street on Twenty-First Street, 1987

Construction of the 41-story office tower.

Prior to the 1980s, developers and architects tended to be respectful and considerate of older Philadelphia. There was the unwritten "gentleman's agreement" whereby no skyscraper would rise higher than the tower of City Hall. And there was the precedent set in the early 1960s by the Society Hill Towers, where architect I. M. Pei respectfully aligned three giant buildings according to sightlines determined by the old brick city below. Pei even used the proportions of the omnipresent double-hung sashes for his own modern windows. These were elegant considerations for a city bound to the past by choice, but beautiful

architecture was not the result. The new Philadelphia rose facelessly. Modernism's tenets had joined forces with an array of gentleman's agreements to assure that architects did not become overly expressive.

Pei returned to Philadelphia in the mid-1980s, when the height agreement had been broken and post-Modernism was in full swing. Commerce Square, his 41-story gray-plaid-and-glass tripartite office tower, had not even a tip-of-the-hat for old Philadelphia. It didn't need to. This was the 1980s; no agenda was required to build tall and fanciful.

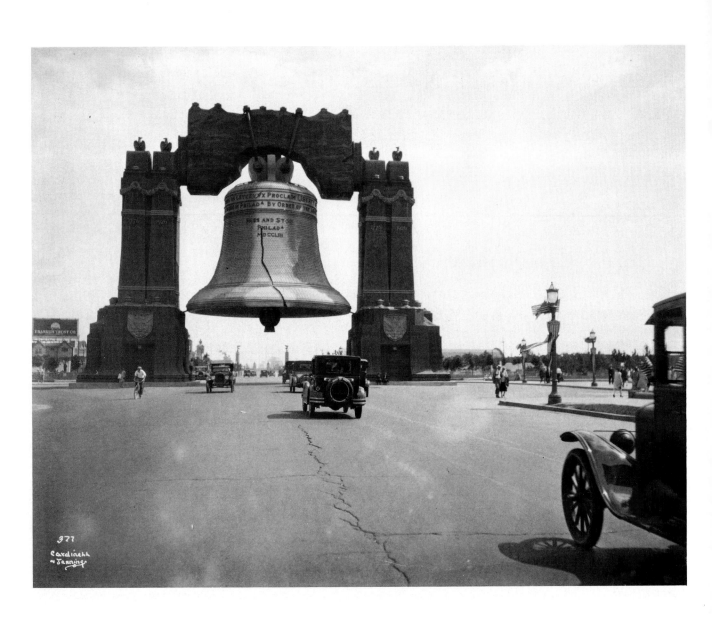

Broad Street, South of Oregon Avenue, 1926

The Liberty Bell: Entrance to the Sesqui-Centennial Celebration of the Declaration of Independence.

In the early twentieth century, political boss William S. Vare, pig farmer turned cement contractor, won a $500,000 contract to shore up the 9000-foot riverbank for a League Island Park. Planners imagined it as "a veritable Coney Island," but that never happened.

Philadelphia's second world's fair was at the base of Broad Street. An 80-foot facsimile of the Liberty Bell marked the entrance to Rainbow City at Marconi Plaza. Its sheet-metal skin was studded with nearly 26,000 15-watt light bulbs. Beneath, a blue, starry dome, lit with additional lights in the giant clapper, was prepared to greet an expected 50 million visitors. The bell was finished in time for opening day, May 31, 1926, but inclement weather—it rained more than half of the 184 days that the exhibition was open—had delayed the completion of many exhibition buildings, and the terraces between them remained swamps. Only ten million visitors showed up. The $5-million loss convinced Philadelphians that the era of international fairs was over.

Broad Street, South of Oregon Avenue, 1987

*Marconi Plaza: The way to and from the Spectrum (home of the Philadelphia Flyers and the Philadelphia 76ers)
and Veterans Stadium (home of the Philadelphia Eagles and the Philadelphia Phillies).*

"It is as though South Broad Street had made up its mind to see all phases of life before leaping into the arms of Uncle Sam at League Island," wrote Christopher Morley in 1920. Between Center City and the Navy Yard, miles to the south, were swampy fens and rural neighborhoods: Stonehouse Lane, the Neck and Greenwich Island. They had been left alone, often forgotten. Now they are gone.

Morley visited the bottom of the city before the Sesqui-Centennial and was pleasantly surprised to find "a new world, a country undreamed of by the uptown citizen." The small white houses and whitewashed fences of Stonehouse Lane seemed as quaint as "a country hamlet, full of dogs, hens, ducks and children." Residents of the Neck, on the other hand, lived in hovels hidden in clumps of trees. It was the city's most poverty-stricken place, "a strange land, with customs of its own, not to be discerned at sight . . . proud and reserved." Philadelphia seemed far away, until a view of the great bend of the Delaware appeared on the horizon.

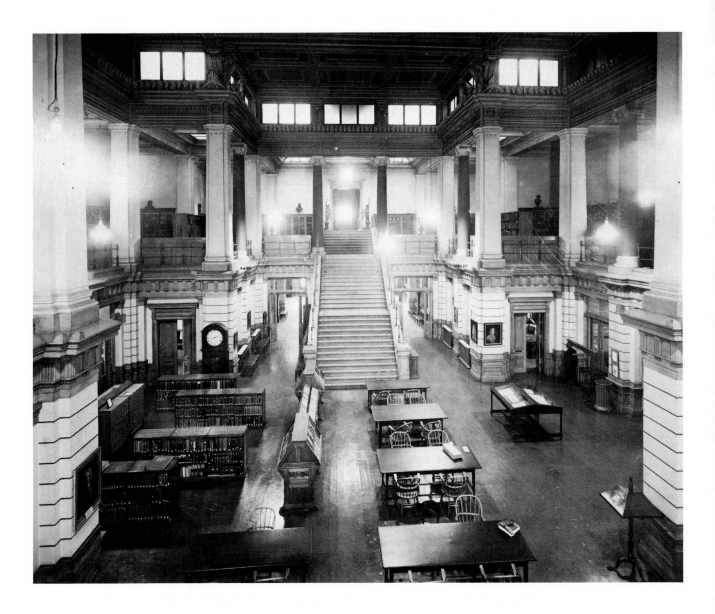

The Library Company of Philadelphia, Ridgway Building, Broad and Christian Streets, ca. 1930

Fourth home of the first American subscription library, founded in 1731 by Benjamin Franklin and friends.

If there is truth to the Library Company's motto—"To pour forth benefits for the common good is divine"—then the deceased James Rush was perhaps divine. The physician, who never practiced but lived the gracious life (spouse Phoebe Ann Ridgway had an inheritance), wrote the Library Company into his will and bequeathed it about $1 million.

Everyone agreed that the nation's first public library had outgrown its building on Fifth Street near Chestnut. Rush intended to fund posthumously the construction of a new facility anywhere between Fourth and Fifteenth, Spruce and Race Streets.

His will also imposed a few quirky bans for the new building. There would be no upholstered chairs, "every-day novels, mind-tainting reviews, controversial politics, scribblings of poetry and prose, biographies of unknown names . . . [or] daily newspapers." Since bequests like Rush's are hard to come by, the library directors did not argue. Unfortunately, in a late, verbal codicil, Rush turned all authority over to his executor and brother-in-law, in whose hands good intentions were lost. The library would soon find itself in an out-of-the-way Doric mausoleum.

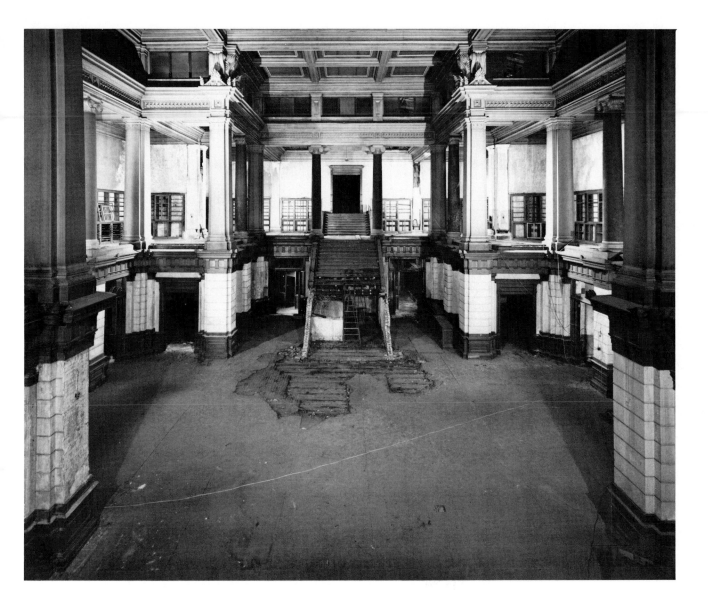

Ridgway Building, Broad and Christian Streets, 1987

After the Library Company moved on.

The building at Broad and Christian Streets was ready for occupancy in 1878. But the directors of the Library Company, loathe to leave Center City entirely, had a Center City branch built at the northwest corner of Locust and Juniper Streets. With the library split, few visitors ventured to the incongruous South Philadelphia headquarters. Christopher Morley appreciated the contrast between its "dim scholarly twilight" and Broad Street's "tumble-down monkey business." Philadelphia nearly forgot its oldest library. When Elizabeth Robbins Pennell visited, she "awoke the attendants and exposed their awkwardness in waiting

upon unexpected readers." This "brought Mr. Lloyd Smith out of his private office, excited and delighted actually to see somebody in the huge and well-appointed buildings besides himself and his staff."

By the 1950s, the location was an openly admitted mistake. The cold, damp, dark and leaky library had more pigeons than readers. In 1966, the Library Company moved to new quarters at 1314 Locust Street. The city bought the Ridgway building and, other than the presence of the Department of Recreation in a part of its cellar, the building entered a long hibernation.

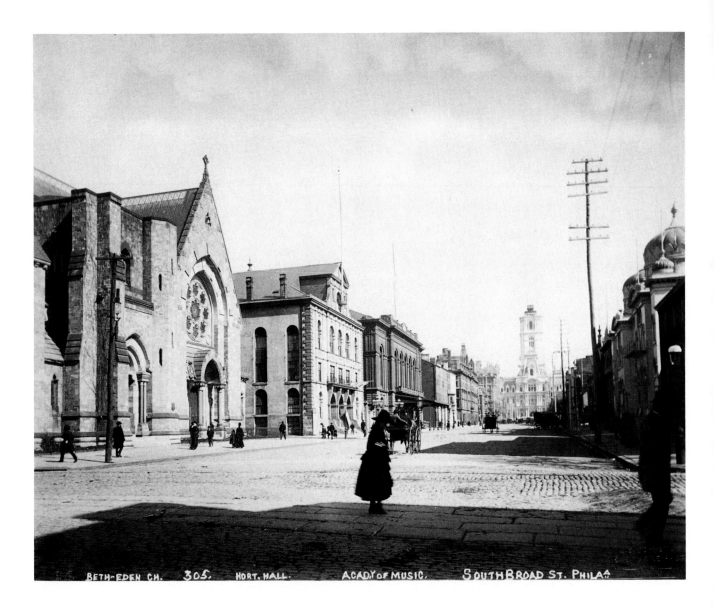

BETH-EDEN CH. 305. HORT. HALL. ACAD'Y OF MUSIC. SOUTH BROAD ST. PHILA?

South Broad and Spruce Streets, Looking North, ca. 1892

Left to right: Beth Eden Baptist Church, Horticultural Hall, Academy of Music,
City Hall under construction (in the distance), Kiralfy's Alhambra Palace.

The southern reaches of Center City ended at Pine Street. Beginning in 1825, when John Haviland built a Greek Revival building for the School for the Deaf at Pine, public buildings were erected up and down Broad Street. They began at Haviland's portico and went as far as Arch Street, north of Penn Square. In 1869, architect E. T. Potter's green and red stone Beth Eden Baptist Church filled out the block started by the Academy of Music

(1855) and Samuel Sloan's Horticultural Hall (first built in 1867). Opposite, on the eastern side of Broad Street, stood the polychromatic onion-domed theater called Kiralfy's Alhambra Palace (later the Broad Street Theatre), built in 1875 and demolished in 1937. It was flanked by three late-Victorian hotels; the Stenton, at Spruce; the Metropole, just to the north; and, at Locust, the Walton.

South Broad and Spruce Streets, Looking North, 1987

Left to right: 260 South Broad Street (offices); Shubert Theatre undergoing renovation as the University of the Arts Theatre; Academy of Music; 230 South Broad Street (offices); Bellevue-Stratford Hotel undergoing conversion to offices, shops and a smaller hotel; City Hall. On the right, at Locust Street, Philadelphia Hershey Hotel.

Philadelphia was an "American city of the large type, that didn't bristle," wrote Henry James, "settled and confirmed and content." And as long as they could hold to it, Philadelphians lined their main street with good, squat buildings that cast more character than shadow.

A fire that destroyed Horticultural Hall in 1882 also claimed the tower of the adjacent Beth Eden Baptist Church. The former was rebuilt, this time from the plans of Addison Hutton. And after the second Horticultural Hall burned in 1893, a Venetian Gothic design by architect Frank Miles Day rose in its place. In 1918, this was rebuilt as the Shubert Theatre (see page 90). The Academy of Music, on the other hand, remained a constant. Its long-time tenant, the Philadelphia Orchestra, eventually chose to build a hall of its own, and in 1987 selected a site at the southwest corner of Broad and Spruce Streets. For the first time in the twentieth century, a new cultural building is planned for Philadelphia's Public Avenue.

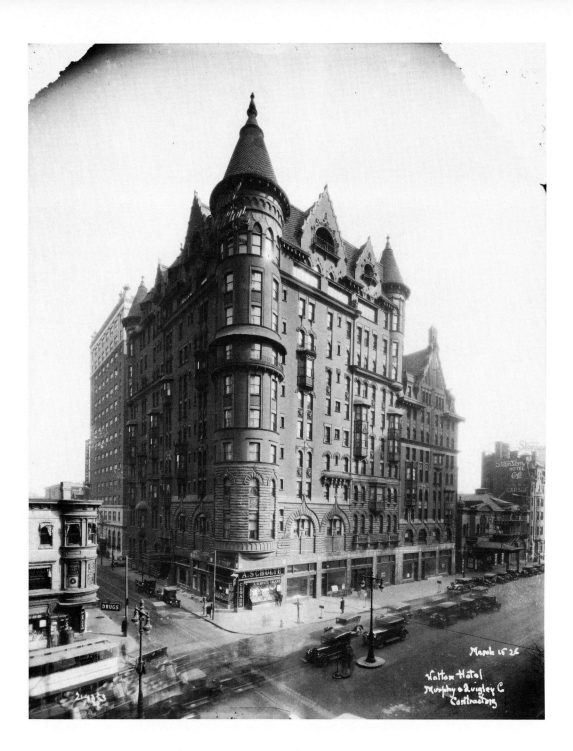

Walton Hotel, Southeast Corner of Broad and Locust Streets, 1926

Left to right: Sylvania Hotel, Walton Hotel, Hotel Metropole.

Angus "Anxious" Wade, an architect whose frenetic style inspired his nickname among architectural historians, worked with hotel developer John N. Sharp at the end of the nineteenth century. Together they built a string of ornate palaces for those passing through.

Wade's Walton Hotel opened for business on February 12, 1896. It had 600 rooms in 14 stories of "fireproof" Pompeian brick. The marble of its foyer floor was heavily veined, the ceilings were vaulted, the stairs symmetrical. The main dining room had Elizabethan strapped-pattern ceilings painted in old-vellum tones, walls lined with onyx and pavonazzo marbles and a floral-patterned carpet. The walls were decorated with paintings of armorial subjects after Watteau and Boucher. The Palm Room, the second-floor restaurant, was in the Venetian Gothic style, paneled in oak. Its windows were hung with red and gold brocades to evoke the feel of old Spanish leather. Once the style of excess had ebbed, few allies for such extreme decor remained. The Walton was demolished for a parking lot in 1966.

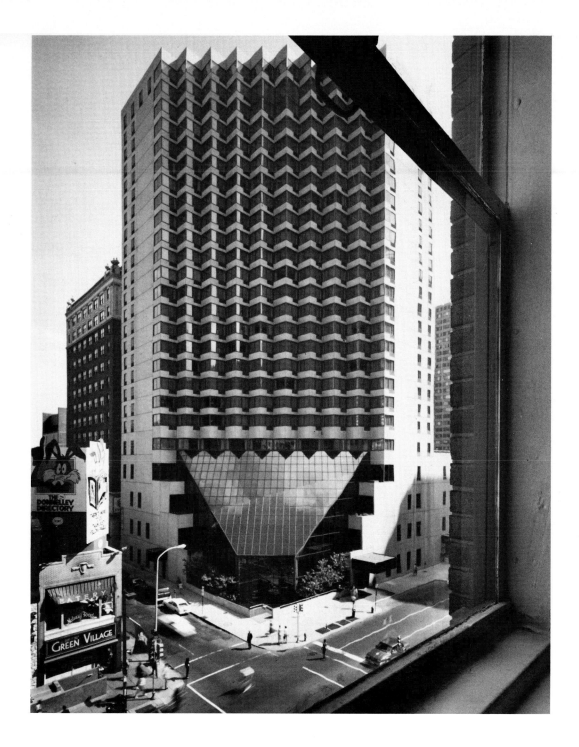

Hershey Hotel, Southeast Corner of Broad and Locust Streets, 1987

Left to right: Sylvania Hotel, Philadelphia Hershey Hotel.

No single stretch in Center City plunged from such heights to such depths as did Locust Street between Broad and Twelfth. In one generation, a row of mansions degenerated into a string of steak houses and strip joints. (The Walton Hotel was known for its speakeasy during Prohibition.) At the northeast corner of Juniper, the 1890s home of art collector Clarence Bloomfield Moore became "Benny the Bum's." Genteel parlors became lurid bars. The "Bag of Nails" and other lounges prospered until police crackdowns. In 1986, there were nearly 700 arrests and the corps of prostitutes moved away.

The long-awaited Locust Street renaissance was signaled when construction started at the southeast corner of Broad. The parking lot where the Walton had been only a few decades earlier was considered a prime site for a modern hotel, and in March 1983, the Philadelphia Hershey Hotel opened.

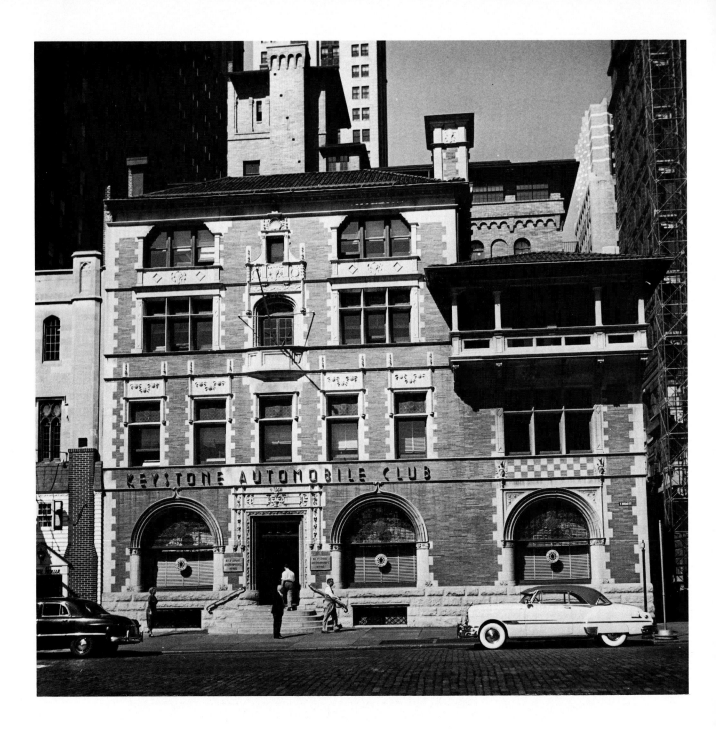

Southwest Corner of Broad and Chancellor Streets, ca. 1952

The Art Club as home of the Keystone Automobile Club.

The Art Club was founded in 1887 "to advance the knowledge and love of the Fine Arts, through the exhibition of works of art, the acquisition of books and papers for the purposes of founding an art library." It was a social club cast as a cultural institution, with a building designed for the dual role.

Unlike Frank Furness' wildly eclectic Academy at Broad and Cherry Streets, Frank Miles Day's Art Club was a restrained and refined brick-and-stone study of the Venetian Middle Ages. There was only a decade between the building of the two, but architectural critic Ralph Adams Cram savored the difference:

> Blessed with an early architecture of the very best type developed on this continent, [Philadelphia architecture] sank first to a condition of stolid stupidity, then produced at a bound a group of men of abundant vitality but the very worst taste ever recorded in art, then amazed everyone by flashing on the world a small circle of architects whose dominant quality was exquisite and almost impeccable taste.

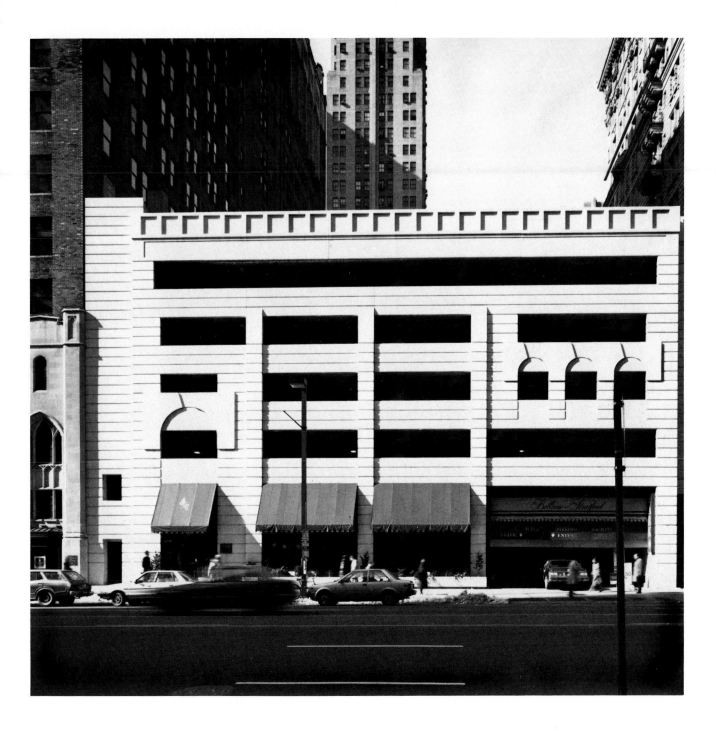

Southwest Corner of Broad and Chancellor Streets, 1987

Parking garage.

Critics praised the Art Club as "a manifestation of delicacy and sweetness, of fine instincts and subtle sympathies." But such kindnesses did nothing for the club's day-to-day operations. On November 9, 1940, the Art Club dissolved, although the building stood for another 35 years, slowly sliding into oblivion. For a time, it appeared to have a reprieve as home to the Keystone Automobile Club. And then a series of losing causes took temporary lodging there: offices of the Philadelphia Bell Football team, George McGovern for President, Thatcher Longstreth for Mayor. But most threatening was the precarious condition of the

Bellevue-Stratford Hotel to the immediate north. Its management wanted more convenient parking for its guests.

A last-ditch effort to make the Art Club building a dining club failed; renovation costs were prohibitive. Hoping against hope, the Philadelphia Historical Commission held up demolition for six months. The owner held off for an additional 14 weeks. But in 1975, the Cleveland Wrecking Company pulled down the Art Club. The foundering Bellevue-Stratford Hotel had, for its few remaining years, convenient parking with a now defunct sushi restaurant.

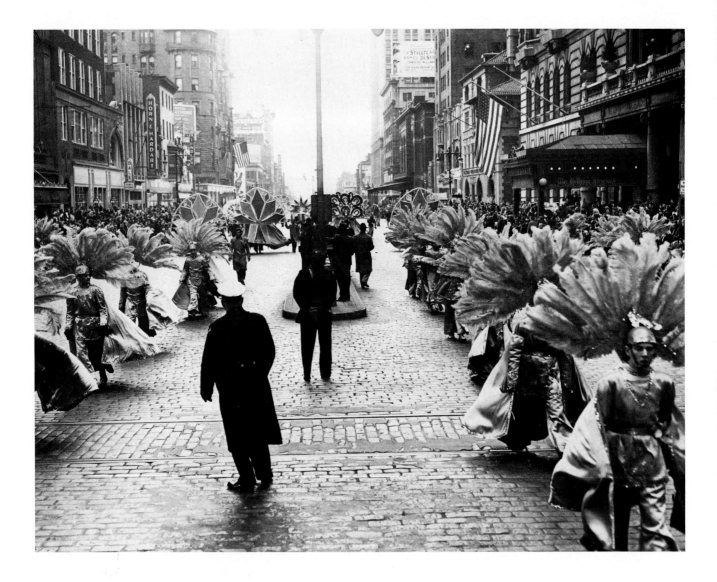

Broad and Walnut Streets, January 1, 1950

Mummers' Parade.

There were mummers—masqueraders—in Finland, Sweden and Britain. And so were there mummers in Philadelphia. Over the years, Philadelphia's New Year's Day mummer celebrations took the form of ad hoc running through the streets with noisemakers (including guns) and costumes (including women's clothing). In the streets of each neighborhood, loosely knit groups of men attempted to outdo others in a day of predictable anarchy. Mummery was finally regulated in the late 1880s and limited to a parade on Chestnut Street.

The parade moved to Broad Street in 1901, when the city offered a winner's purse of $1725. Television coverage began in 1949, color broadcasts in 1956. The length of the official parade expanded from a few hours to the entire day. More than 20,000 mummers now march in clubs with various themes that change from year to year. It takes more than 12 hours for the mummers to make their way up Broad Street.

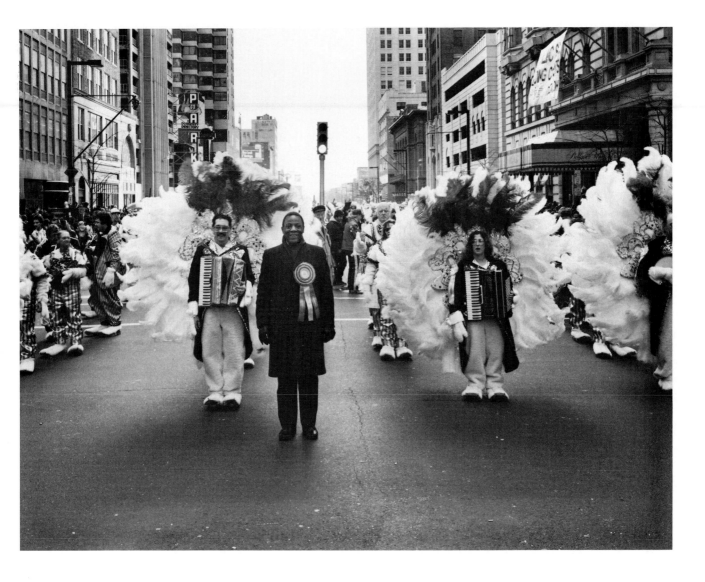

Broad and Walnut Streets, January 2, 1987

Mayor W. Wilson Goode and the Wildwood String Band, Mummers' Parade.

Many people stayed indoors on New Year's Day 1987, observing the national rite of televised college football bowl games (five were aired that day). Among those who ventured from their couches were a million folks in Pasadena, California, who came out to see 59 flower-covered floats and a mechanical King Kong. In Philadelphia, where the Mummers' Parade had been scheduled, Broad Street was sadly silent. A forecast of sleet had caused the Deputy Commissioner of Recreation to postpone the Mummers' Parade. For all intents and purposes, New Year's Day was delayed for 24 hours.

The mummers strutted their $2.5 million in sequins and feathers on a not-so-blustery January 2. And Mayor W. Wilson Goode, representing the city and its $1.4-million contribution to the day's events, joined the Wildwood String Band (theme: "Purr'fect Night to Dance"). It was a 12-hour extravaganza with 54 clubs and 20,000 mummers in all. Who could forget the Goodtimers (Comics); the Hog Island Club (Fancy Costumes); Harrowgate, Fralinger and Ferko (String Bands); and Shooting Stars, Merrymakers and Satin Slipper (Fancy Brigades)?

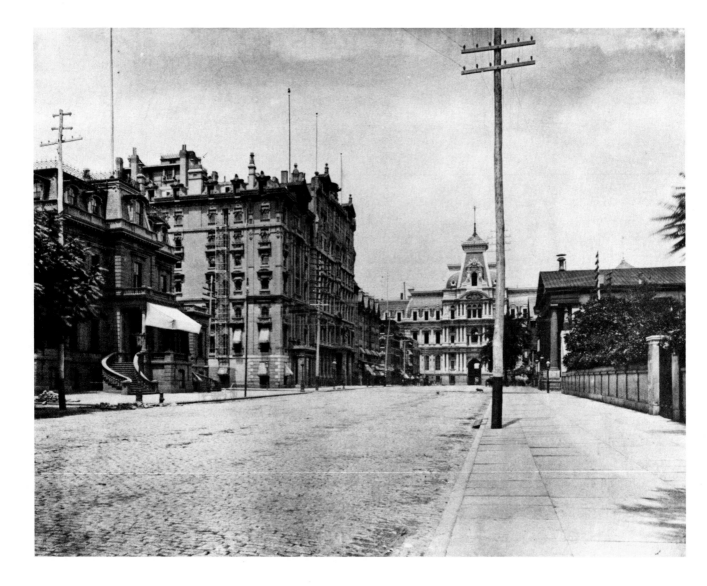

Broad and Walnut Streets, Looking North, 1885

*Left to right: Union League of Philadelphia, Hotel Lafayette, City Hall, First Independent
Presbyterian Church, garden wall of the Dundas-Lippincott mansion.*

" 'Broad and Chestnut,' " pointed out guide Christopher Morley,

is a Philadelphia phrase of great sanctity. It is uttered with even greater awe than the New Yorker's "Broadway and Forty-second," as though the words summed up the very vibration and pulse of the town's most sacred life. And yet why is it that Broad Street seems to be more at ease, more itself, when it gets away from the tremendous cliffs of vast hotels and office mountains? Our Philadelphia streets do not care to be mere tunnels, like the canyon flumes of Manhattan.

In Morley's Philadelphia of the 1910s, Broad and Chestnut had only recently lost its perfectly urban, pleasantly open, main-street look. Photographer Frederick Gutekunst captured this stretch just before the change—before the smattering of clubs, hotels, theaters and churches was transformed into a traffic-filled mercantile canyon.

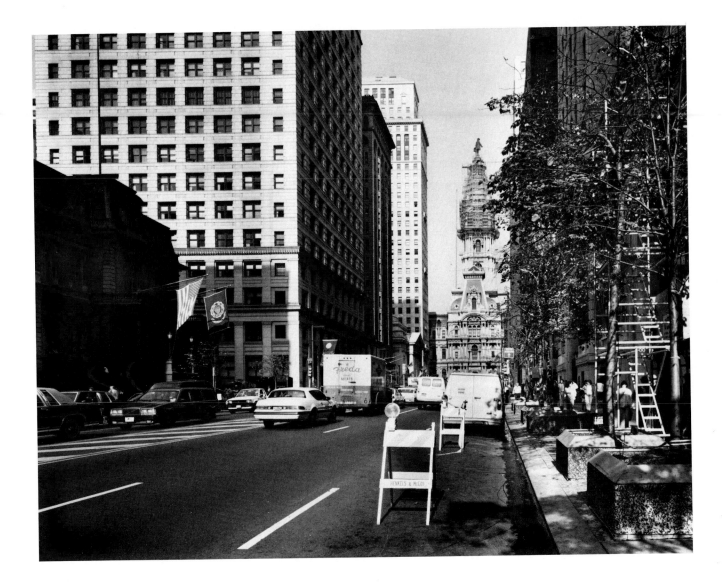

Broad and Walnut Streets, Looking North, 1987

*Left to right: Union League of Philadelphia at Sansom Street,
Land Title Building to Chestnut Street, City Hall.*

A competition in skyline domination started in the late 1880s. With designs by Quaker architect Addison Hutton, Girard Trust Company (old money) built an eight-story building at the northeast corner of Broad and Chestnut. Two years later, beer baron John F. Betz (new money) acquired the site to its north, hired architect Will H. Decker and instructed him to build even higher than Girard Trust. The Betz Building had no old Philadelphia pedigree, but it had the edge. The Girard Trust might have simply given up, but pride was at stake here. So Girard built an additional six stories. Betz matched the height and added some more.

The building boom on South Broad Street was under way. Between the Union League and City Hall there were several towers: the Land Title Building, the North American Building and the West End Trust were built, almost in unison. Between their shadows, the Girard Trust Corn Exchange Bank (now Mellon Bank) staked out its confident claim, not in the skyline but in cool white marble at street level.

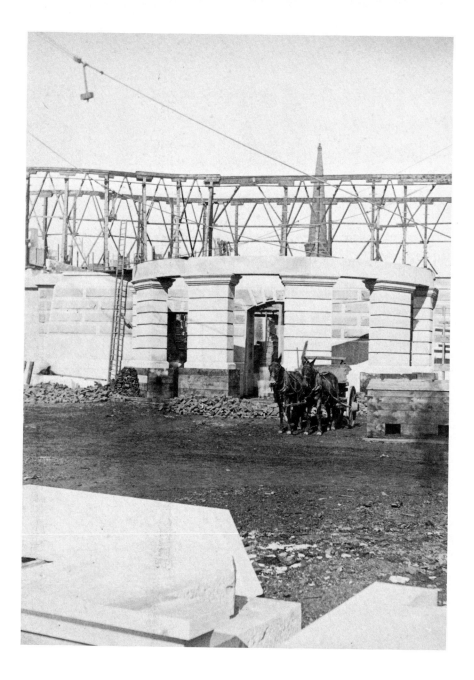

Penn Square, 1875

Philadelphia's center: construction of City Hall.

Before they built up, they dug down. City Hall tower begins with an eight-foot-thick slab of concrete 23 feet below grade. But before they dug at all, they had to decide where to build, a debate that started in 1838, 33 years before ground was broken at Penn Square. Some people wanted to keep the municipal government at Independence Square; others felt that Penn Square would be the right place for relocation. When a model for a three-sided city hall on Independence Square was unveiled around 1860, the State Legislature acted to protect Independence Square from this municipal intrusion. The city, meanwhile, would not buy a building site. So the citizens were given a choice: Washington Square or Penn Square.

A referendum was held and Penn Square won. And, in spite of protests against building on one of the five original city squares, the project was begun. At the cornerstone-laying ceremonies on July 4, 1874, Benjamin Harris Brewster proclaimed that the building "is placed, as other and great structures are, at the center of human concourse from which all things radiate and to which all things converge."

City Hall Courtyard, 1987

Philadelphia's center: renovation of City Hall tower.

What was swiftest to rise during those first years, however, was criticism. As City Hall was erected behind a railroad-bearing scaffolding (an engineering feat in itself), the project acquired a variety of nicknames: "the marble elephant" and "the marble maw." Contractor-corruption trials started almost at once. Mayors added it to their repertoire of banquet humor. As if adding insult to injury, the designs had gone out of style. "The artistic failure of City Hall was apparent before it was half-finished," summarized a critic in 1910. And architect Ernest Flagg, speaking at a national city-planning conference one year later, claimed that "if the design were as good as it is bad . . . the building [would be] the finest architectural creation of modern times."

Even Walt Whitman was contrary about City Hall:

Returning home, riding down Market street in an open summer car, something detain'd us between Fifteenth and Broad, and I got out to view better the new, three-fifths-built marble edifice, the City Hall, of magnificent proportions—a majestic and lovely show there in the moonlight—flooded all over, facades, myriad silver-white lines and carv'd heads and mouldings, with the soft dazzle—silent, weird, beautiful—well, I know that never when finish'd will that magnificent pile impress one as it impress'd me those fifteen minutes.

Renovation of City Hall tower, costing nearly $18 million, is expected to be completed by January 1990, the centennial of the death of the building's architect, John McArthur, Jr.

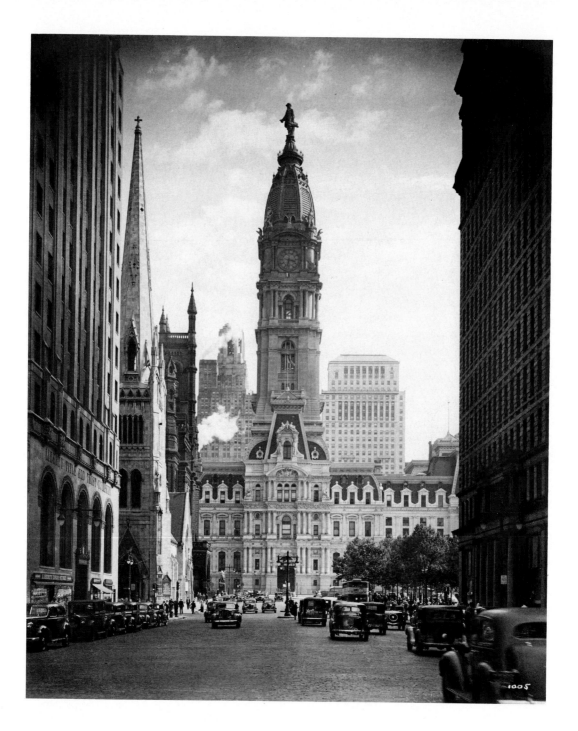

From Broad and Cherry Streets, Looking South to Arch Street and Penn Square, 1938

*Left to right: Liberty Title and Trust Company, Arch Street Methodist Episcopal Church, Masonic Temple,
City Hall, United Gas Improvement Building.*

Never delighted with City Hall, officials often considered tearing it down. The most recent serious proposal, in 1952, would have left the tower as a traffic island. But that was on the eve of the Center City revival, at the beginning of renewed interest in Victorian architecture. In another decade or two, City Hall was in the running as the most unusual, possibly the most beautiful, nineteenth-century American building.

The intricate and unusual sculptural program of City Hall—still something of a mystery in its complexity—featured at its pinnacle a heroic statue of William Penn. Artists had forged a niche for Penn in the local imagination, paving the way for Alexander Milne Calder's 37-foot figure above the city. The public's first contact with Calder's rendition of this Quaker Zeus was at ground level in City Hall courtyard. Penn's waist measures 26 feet; his somber eyes nearly a foot. The public loved it. But architect and sculptor feuded, and Penn was installed with his face away from the sun, or "condemned to eternal silhouette," as Calder later said.

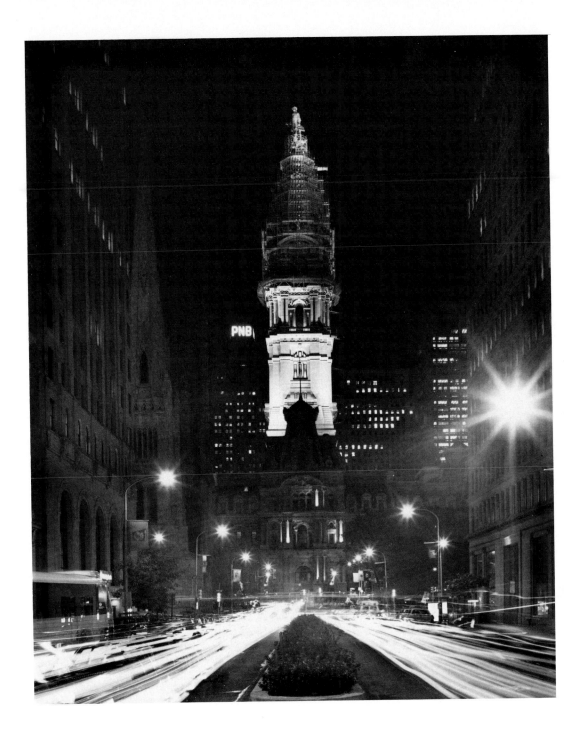

From Broad and Cherry Streets, Looking South, September 14, 1987

Unveiling the restored statue of William Penn.

Just as the years separate modern Philadelphians from William Penn, those who look to the tower of City Hall are separated from Penn's likeness by a pageant of historical sculpture. On pediments, panels, cornices and capitals that grace City Hall's facades, sculpture illustrates the founding, settling, industrialization and education of Pennsylvania.

Over the years, all of the sculptures have deteriorated, especially the figure of Penn. Scaffolding was installed and funds for restoration of the tower were allocated by the City Council, but refurbishing the Penn statue was left to the citizenry. A dedicated committee formed and pledged to have the statue free of scaffolding in time for the Constitutional Bicentennial celebration. "Free William Penn" buttons were sold and corporate contributions were solicited. A patinist was hired and her crew worked long days through the summer. They beat the Bicentennial. The scaffolding was removed, and a great gauzy veil draped over the statue's new bronze glow was ceremoniously shed the night of September 14, 1987. William Penn was free.

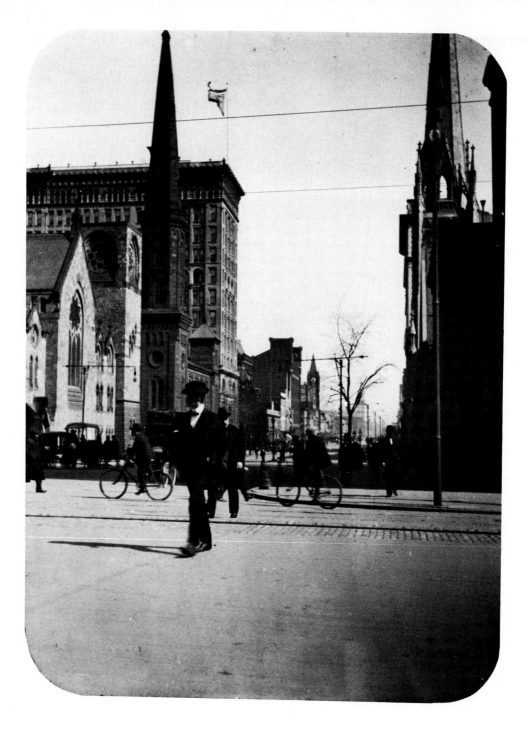

Broad Street, North from City Hall, 1898

The churches of Broad and Arch Streets (left to right): Lutheran Church of the Holy Communion,
First Baptist Church, Arch Street Methodist Episcopal Church.

A full generation before City Hall was a glimmer in a contractor's eye, Broad Street real estate was affordable and desirable. During the third quarter of the nineteenth century, churches, theaters, clubs, hotels and halls were built. Hotels seemed to be more at home south of Penn Square. But three of the six churches that cropped up between Arch and Lombard Streets were clustered at Broad and Arch. Addison Hutton's white-marble Methodist church in English Gothic Revival style was joined by Stephen Decatur Button's spired First Baptist Church on the northwest corner, with Furness and Hewitt's Lutheran Church of the Holy Communion at the southwest corner. Combined with the Pennsylvania Academy of the Fine Arts at Broad and Cherry, and the Masonic Temple at Broad and Filbert, the area just north of City Hall had become a veritable museum of architectural styles.

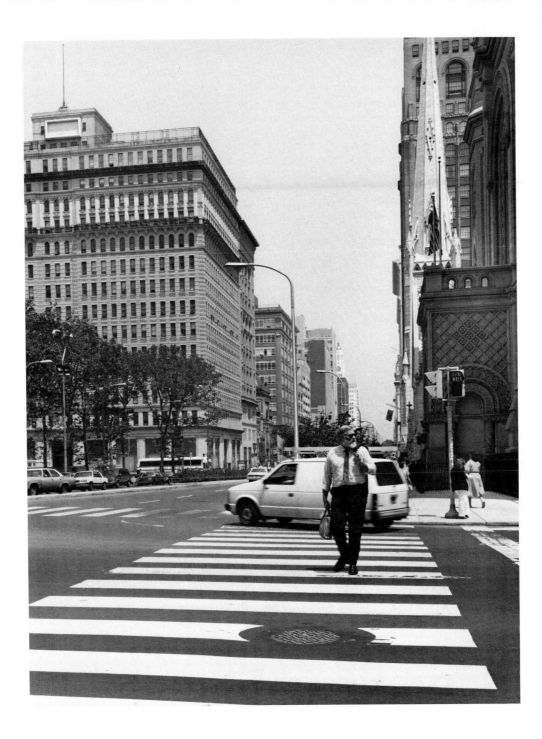

Broad Street, North from City Hall, 1987

*Left to right: The United Gas Improvement Building, tower of the Arch Street
United Methodist Church, portico of the Masonic Temple.*

As office buildings began to replace the nineteenth-century institutional homes, the high-rise structures literally placed the remnants of the past in shadows. The United Gas Improvement Company building loomed in the 1890s where the First Baptist Church had soared in the 1850s. Usable, not necessarily meaningful, height was of key importance. The UGI building was extended once in the 1920s, and a larger extension, planned in the mid-1980s, was not carried through. Indeed, all office development seemed to be concentrated west of City Hall. North Broad Street, however accessible, would have to wait its turn.

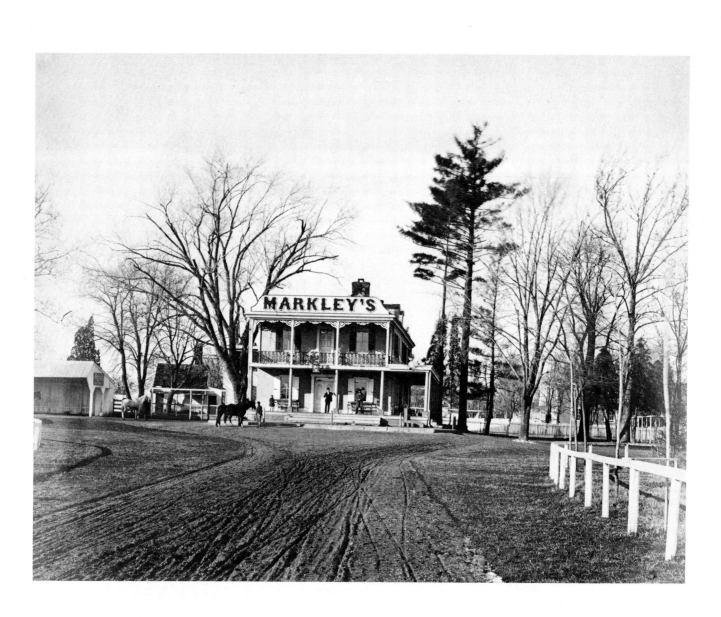

Broad Street and Erie Avenue, Northwest Corner, ca. 1875

Where Broad Street, Erie Avenue and Germantown Avenue cross: Markley's Tavern.

Farther north on Broad Street, public buildings gave way to fancy residences which, in turn, gave way to farmland. Here the rat race was replaced by the horse race. Broad Street jockeys finished at such destinations as the Lamb Tavern and the Punch Bowl, where pugilists and politicians also gathered. Where Germantown Road and Erie Avenue crossed Broad Street, there were more races at a track near Markley's Tavern. But these taverns fell out of favor with the ward heelers and were inherited by bands of horse-trading, fortune-reading gypsies. By the end of the nineteenth century, members of the city's growing managerial and entrepreneurial class built new homes here. Growth was rapid. In the summer of 1863 alone, more than 160 houses were built in the mile north of Poplar Street. By the 1890s, residential building had reached Erie Avenue. The tavern-crawling population of North Broad Street was gone, replaced by wholesome families and their commodious row houses.

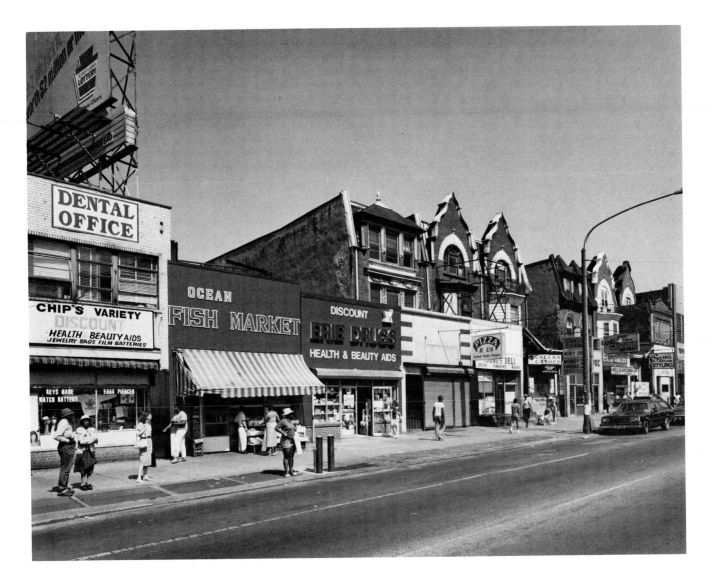

Broad Street and Erie Avenue, Northwest Corner, 1987

Where the Broad Street subway, No. 23 and 56 trolleys and buses C, H and XH converge:
row houses converted into a commercial strip.

The growing suburb had consumed the city's northern fringes. North Broad Street grew in much the same manner as South Broad. Beyond Center City, where City Hall hovered in the distance, it turned scenic and mostly residential. Brownstone palaces for the families of Matthew Baird (locomotives), Peter A. B. Widener (transportation), William Gaul (beer) and Edwin Forrest (theater) graced broad lots. On the blocks between them, generously proportioned row houses appeared.

The Reading and the Pennsylvania Railroad lines crossed near Broad Street and Lehigh Avenue. Stations there, as well as the later presence of the Broad Street subway, soon contributed to a growing industrial life. In the late twentieth century, North Broad Street was known for its garment mills, car dealerships, empty opera houses and the urban campus of Temple University.

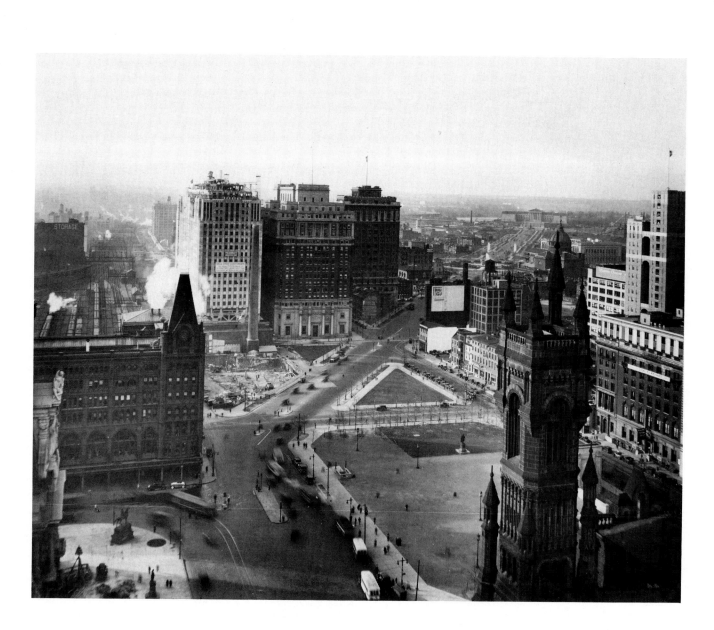

Benjamin Franklin Parkway, from City Hall Annex, ca. 1930

Left to right: Broad Street Station, Suburban Station, Insurance Company of North America Building,
Bell of Pennsylvania. Masonic Temple tower in the right foreground.

Early twentieth-century Philadelphians were troubled. With the construction of City Hall at Broad and Market Streets, perhaps the greatest crossroads in urban history was in their midst. Yet they had no sweeping vista from which to see it. Moreover, Philadelphians had the largest and most impressive city park in the world. Yet they had no grand entrance to it. The brains and lungs of the city (as some called City Hall and Fairmount Park) were finally mature but decidedly unconnected.

The idea for a formal approach and entrance to the park, first broached in 1871, the year ground was broken for City Hall, took a generation or two to evolve into the Parkway. By the time plans were completed in 1918, the Benjamin Franklin Parkway was a highly developed visual, conceptual and actual connection between the city's most significant building and its most significant open space.

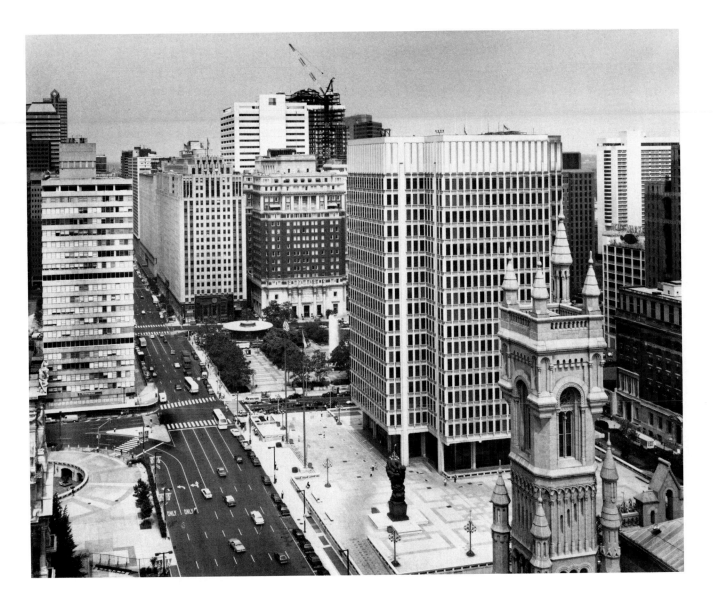

John F. Kennedy Boulevard, from City Hall Annex, 1987

*Left to right: Penn Center, Suburban Station; Insurance Company of North America Building,
John F. Kennedy Plaza, Municipal Services Building, Masonic Temple tower.*

In 1907, 35 years after the Parkway idea was presented, the Fairmount Park Art Association hired three architects to make their recommendations. With a blush of optimism characteristic of the century's first years, Horace Trumbauer, C. L. Borie and C. C. Zantzinger considered the Parkway as if it were a fresh idea. With a mind to the past (if accidental) success of Broad Street, the architects proposed that their Parkway be restrained as it approached City Hall. "We feel that this radiating avenue should not dominate Broad Street," the architects wrote of the stretch from Logan Circle to City Hall, but that it "would assume a character not unlike that of Broad Street below City Hall."

The funnel-like effect of the Parkway starts with a generous breadth at Fairmount and gently tapers before it is tamed at Logan Square. But the existing seventeenth-century Logan Square would not do. In the final Parkway design, Jacques Gréber respectfully and tastefully converted it into a grand swirl of a circle, a final reflection of the park's exuberance before getting down to business in the city.

53

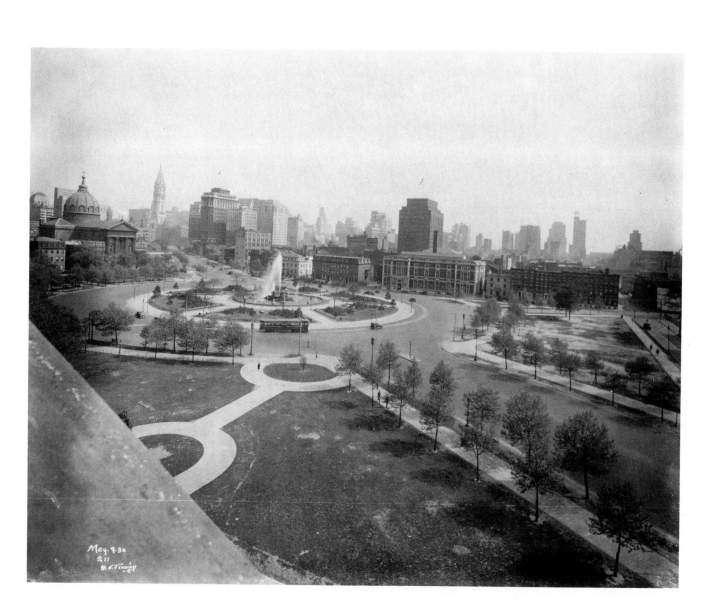

Logan Circle, from the Free Library of Philadelphia, May 9, 1930

Left to right: Cathedral of Saints Peter and Paul, City Hall,
Academy of Natural Sciences (to the right of the fountain).

If an architectural think tank solved the problem of connecting park and city, it was the dynamics of politics and society that made it happen. Heading the Fairmount Park Art Association was financial magnate Edward T. Stotesbury; he represented raw ambition. Heading the Fairmount Park Commission was Eli Kirk Price; he represented a take-the-helm leadership of Old Philadelphia. Their combined forces did much, though they might have done more, had it not been for the First World War, the Depression and Philadelphia's inclination to conservatism.

When Mayor Freeland W. Kendrick addressed the crowd at the opening of the Free Library on June 2, 1927, he expressed his

hope that all of cultural Philadelphia would follow the city library's lead and move to the Parkway. The library had, in fact, escaped its cramped quarters diagonally across from the Historical Society at Thirteenth and Locust Streets. But the older cultural institutions tended to shy away from wide-open, modern spaces. They shunned the freshly planted plain of the Parkway for the crowded streets of Center City. Only the Franklin Institute moved out, making a modest cultural neighborhood with the Boy Scout Headquarters, the School Board building, a new museum for Rodin casts and the Philadelphia Museum of Art.

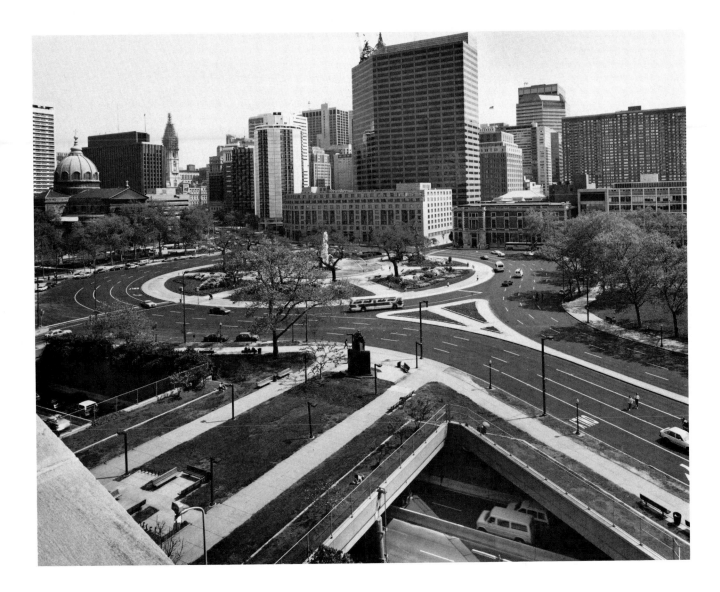

Logan Circle, from the Free Library of Philadelphia, 1987

Left to right: Cathedral of Saints Peter and Paul, Palace Hotel (round tower), Four Seasons Hotel with One Logan Square office building (slab). Bottom: Vine Street Expressway. (Photograph by Jeffrey Hurwitz.)

The Parkway planners had a long agenda, possibly too long. It did provide City Hall with a sweeping vista that would not be threatened for some time. But in the late twentieth century, the Parkway is barely remembered for the way it merged park and city. Nor has it fulfilled its intended role as Philadelphia's cultural mall. Instead, the Parkway's ability to welcome the automobile into the city made it an instantly successful, if incredibly short, highway.

The "garden city movement," conceived to remedy damage done by industry to the appearance of cities, created these boulevards that accommodated the automobile. Planners im-

mediately saw the ironic mistake. At a city-planning conference in 1916, one Philadelphian predicted that the automobile would reshape the city of the future. Another planner suggested that "the city street of the future must be wide—very wide, to allow for a line of stationary vehicles near the sidewalk, a line of slow-moving vehicles next and a line of fast-moving vehicles in the center." Cities were filling up with cars. "It is not an uncommon sight to see the entire space along the curb occupied by motorcars for hours at a time." By the mid-twentieth century, underground highways provided even better vehicular access to Center City.

Swann Memorial Fountain, Logan Circle, Looking East, Winter 1924-25

Swann Memorial Fountain and the Cathedral of Saints Peter and Paul.

Dr. Wilson Carey Swann founded the Philadelphia Fountain Society in 1869 to provide watering troughs for horses. Funds bequeathed by his widow to build a memorial to Dr. Swann were presented to the Parkway project just as the centerpiece at Logan Circle was in the design stage. Architect Wilson Eyre and sculptor Alexander Stirling Calder designed a fountain that would represent Philadelphia's two rivers and major creek: Delaware, Schuylkill and Wissahickon. Work started on the fountain in the spring of 1919 and finished with a reception on the evening of July 24, 1924. As sweltering heat enveloped the 10,000 people who had come to watch, the water in the Swann Memorial Fountain glistened for the first time in a delightful configuration of arching and crossing streams. The Police Band played as celebrants danced in the streets. During its first winter, the Swann Fountain became a giant ice sculpture.

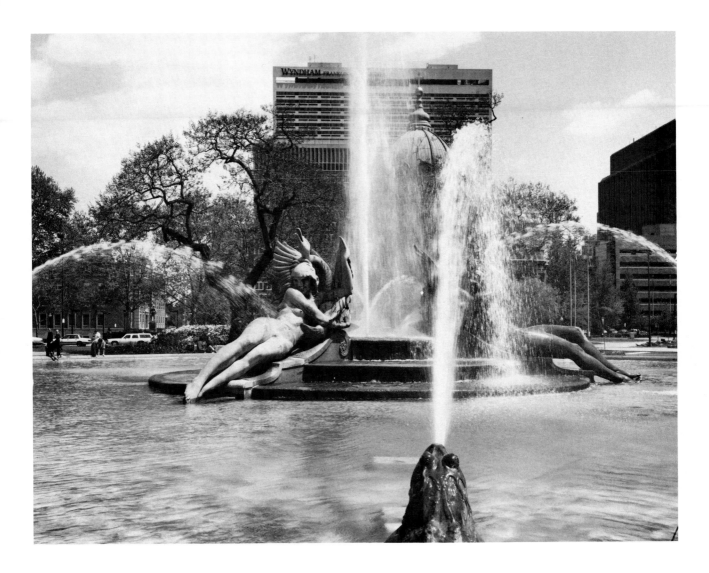

Swann Memorial Fountain, Logan Circle, Looking East, Summer 1987

Swann Memorial Fountain, the Cathedral of Saints Peter and Paul and the Wyndham Franklin Plaza Hotel.

Logan Circle has always been the site of celebratory gatherings and parades for Thanksgiving Day, Pulaski Day, Columbus Day, St. Patrick's Day, Von Steuben Day, Israel's Independence Day and Super Sunday. There is even a graduation day ritual in which students of the nearby Hallahan High School dance in its shallow pool. Philadelphians grew proud of their most prominent fountain, encircled by angular paulownia trees and flower beds that are traditionally cared for better than any other garden in Fairmount Park.

As time passed, ten of the fountain's 16 bronze frogs, turtles and swans ceased to spout water. A few spouted too much. The city and the Swann Memorial Fund contributed $150,000 each for reconstruction, but the new plumbing, pumps and lighting would cost nearly four times that amount. In 1987, several local foundations, corporations and the Girl Scouts of America pledged the balance. Proceeds from the sale of $25,000 worth of cookies were set aside to fix the crippled waterspout menagerie.

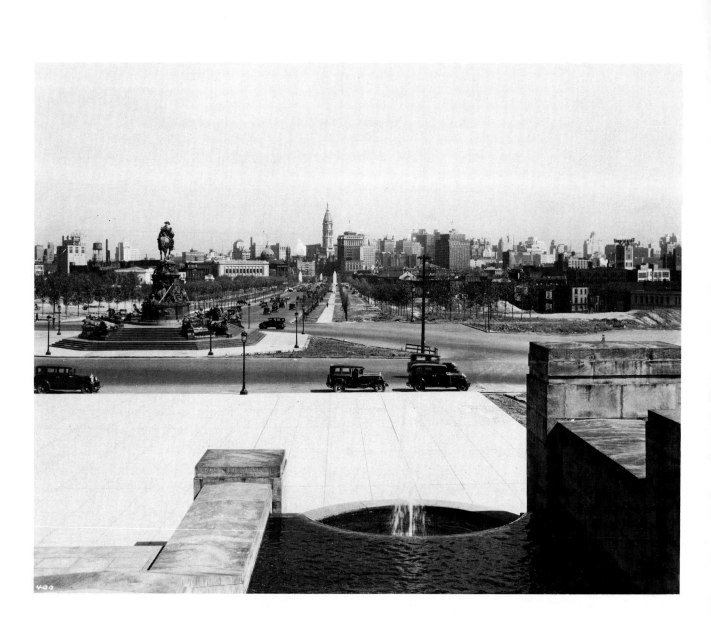

Center City Skyline, from the Steps of the Philadelphia Museum of Art, ca. 1928

*Rudolf Siemering's George Washington monument at the head of the Benjamin Franklin Parkway,
southeast to City Hall.*

Initially, the termination of the Parkway was to be plain and simple. City Hall would be at one end; a green mount would be at the other. But in 1895, a new art museum was proposed for the hill past Fairmount, a place called Lemon Hill. Before long it merged with the Parkway plan. The visual terminus of the Parkway would be a grand piazza and a grand museum building, up a grand flight of stone steps.

The architects envisioned something along the lines of Rome's Piazza del Popolo. Then, in a "purist vision of doctrinaire modernism," as one architectural historian called it, architects designed the piazza in the hope that the city's various fine-arts institutions, including the Pennsylvania Academy of the Fine Arts, the School of Industrial Arts and the architecture department of the University of Pennsylvania, would relocate nearby. They did not. And so the museum and its bronzes, including Albert Wolff's *Lion Fighter,* installed in 1929, preside over the Parkway alone.

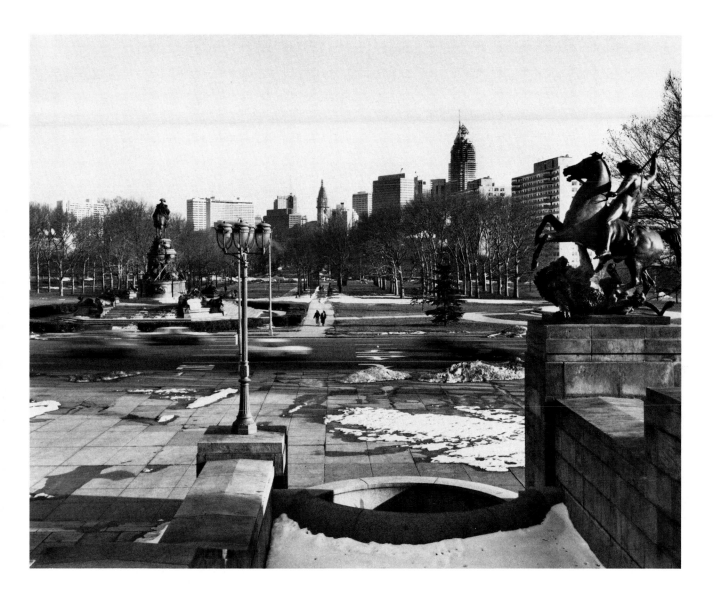

Center City Skyline, from the Steps of the Philadelphia Museum of Art, 1987

Eakins Oval and the Washington Monument at the head of the Benjamin Franklin Parkway. City Hall (center), One Logan Square and One Liberty Place (unfinished, right). The Lion Fighter *(right).*

Opponents of the arts boulevard proposed by the Fairmount Park Commission's Eli Kirk Price had a name for it: "Eli's Cultural Slum." The expanded arts boulevard never materialized. Indeed, the transition from a reservoir to a new museum on Fairmount was complicated and expensive enough, and led to several municipal bungles. Each one was reported in the newspapers. One well-placed contractor was paid to remove a large portion of Fairmount—and then was paid to move it back.

A gentlemanly committee, unwilling to offend, hired three competing architects for the museum commission. It was not a

brilliant choice, and it was not a brilliant building. It offended both extremes of its broad constituency. Contemporary artists called it a "Greek garage." Stodgy society patrons objected to a beer party that was given for construction workers when the galleries were completed. The lack of identity was illustrated when wealthy benefactor Arthur H. Lea died, leaving the museum funds and an art collection if its name was changed from the Pennsylvania Museum of Art to the Philadelphia Museum of Art. It was.

Reservoir Hill, ca. 1875

Rustic gazebo overlooking the Fairmount Waterworks and the Schuylkill River.

Philadelphia was fairly flat, save the odd bump at its northwest corner. It was dubbed "Faire Mount" by William Penn, and he planned to tame it with grape arbors. But early settlers soon learned that Philadelphia's climate was ill-suited for viticulture. Fairmount was, after all, largely rock. What Penn had dreamed would be a little of the Old World poking outward became a gentle tapping of the wilderness on Philadelphia's shoulder.

Fairmount did not start out as a park, though it lent itself to the idea of one. In the early nineteenth century, Fairmount became the site of a reservoir for the new city waterworks. Philadelphians flocked to promenade along its landscaped serpentine paths. And when this was expanded in 1840 to include the adjacent 45 acres of Lemon Hill, that, too, became an instant attraction. Parcel after parcel of land was added to Fairmount over the next three decades, protecting the city's water supply and lining both sides of the river with thousands of acres of protected land. The world's largest city park was in the making.

Behind the Philadelphia Museum of Art, 1987

Path from the Fairmount Waterworks overlooking the Schuylkill River.

As long as Fairmount Park's 2700 acres served the dual purpose of city beautification and water purification, there was unwavering municipal commitment. But by the beginning of this century, when both the capacity and the quality of the waterworks system declined, the city abandoned Schuylkill water for Delaware water. Instantly, the park changed from a public utility to a public obligation.

By the mid-twentieth century, maintenance of the one-time civic treasure proved burdensome. Each year, the Fairmount Park Commission requested a larger appropriation from the city. But instead, the park's share of the city budget steadily declined. At first, the upkeep needed for ornamental gardens and structures seemed modest. And then the situation worsened. Trees stood unpruned; fields went unmowed; abandoned historic mansions were vandalized and some vanished. Only when the concrete swath of the Schuylkill Expressway ravaged the park in the 1950s was the sad decline of Fairmount Park finally apparent.

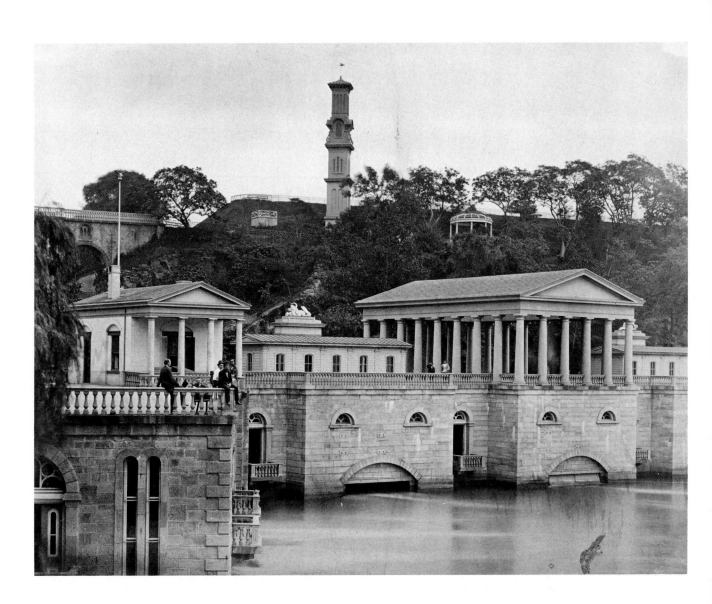

Fairmount Waterworks, Schuylkill River, ca. 1875

*Left to right: Watering Committee Building, North Entrance House,
the Pavilion, standpipe on Reservoir Hill.*

Beginning in 1801, water from the Schuylkill River was pumped to a Neoclassical tower at Center Square. But the growth of the city rendered that white marble pumphouse obsolete after only a dozen years. A site for new mill buildings was soon blasted out of the rock at the foot of Fairmount. And the Neoclassical buildings erected there, designed by Frederick Graff, were occupied by mills and engines. An elegantly covered single-span bridge added to the classical references, reminiscent of works of Roman engineering. Two famous sculptures decorated the entrances to the waterworks buildings: William Rush's carved reclining figures,

Schuylkill Chained and *Schuylkill Freed*. Lining the switchback paths of Fairmount were the sculptor's carved figures: *Nymph and Bittern, Mercury* and the attributes of *Mercy* and *Justice*. It all seemed to suggest, perhaps, that these waters were now tamed in the best tradition.

Country retreats set on the bluffs continued the civilized theme of Fairmount. On the east side, visitors to the waterworks could see mansions that overlooked the Schuylkill—Lemon Hill, Sedgeley and the Cliffs. On the west side stood Eaglesfield, Lansdowne, Sweetbrier, Solitude and Belmont.

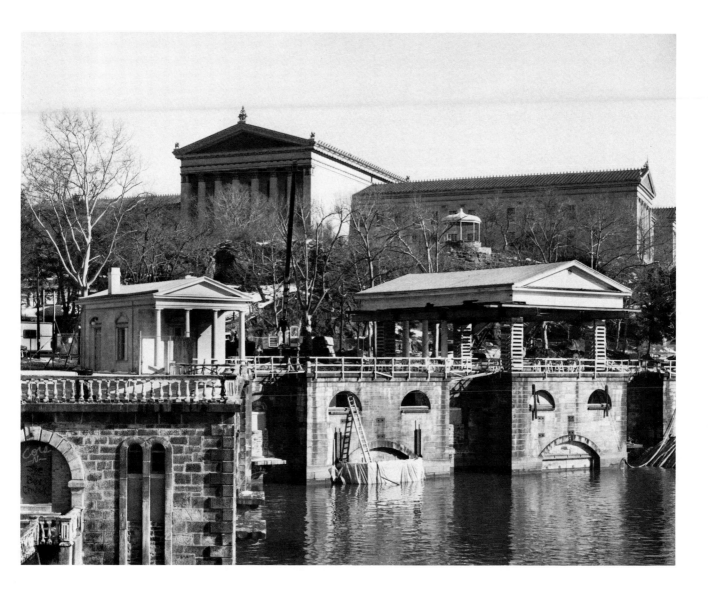

Fairmount Waterworks Undergoing Restoration, Schuylkill River, 1987

Left to right: Watering Committee Building, North Entrance House,
the Pavilion, Philadelphia Museum of Art (above).

Philadelphians wanted to believe that their legendary waterworks would never leave them wanting. But Fairmount was a rather small operation, as large cities go, and by the middle of the nineteenth century, Philadelphia emptied its reservoir twice a week. Droughts further eroded confidence in Fairmount, and annual outbreaks of typhoid ended it. The Neoclassical ensemble that once represented Philadelphia's benevolent grip on nature had become a symbol of the city's inability to care for its basic needs.

The obsolete waterworks became an aquarium. People no longer came to see the waterworks, but to visit its 1500 fish and a giant loggerhead turtle named Dover. In 1960, the complex was added to the National Register of Historical Places. Then the aquarium closed and the buildings sat vacant. Restoration began in the mid-1980s. Before long, the caretakers' houses were completed, the pavilion's wooden columns were restored or replaced, and casts of the Rush figures were readied for installation. A hydroelectric plant and an "interpretative center" were considered for the cavernous spaces below the buildings; a restaurant and café are likely above.

The Schuylkill River, from the Philadelphia Skating Club and Humane Society, ca. 1865

Downriver towards Fairmount Waterworks, with a glimpse of the Center City skyline.

Rowing in summer, skating in winter: These were the passions of athletic Philadelphians. And as ponds in the city were drained and filled in, skaters donned their buckskins and took horse-drawn omnibuses to Fairmount to cut the "Philadelphia salute."

During an extended cold snap in 1849, the Philadelphia Skating Club and Humane Society joined to patrol the ice for those in danger. Its members wore badges—miniature silver skates—and carried coils of rope. Ladders, grapnels, hooks and lifeboats were available for more elaborate rescues. Such patrols saved hundreds of lives during the first decade and earned the club the right to build its headquarters on the riverbank's first bend, above the waterworks. The brownstone building had a second-story deck that offered photographer John Moran the widest possible view of the Schuylkill.

Philadelphia Girls Rowing Club, No. 14 Boathouse Row, 1987

Toward Undine Barge Club and Center City.

The Philadelphia Skating Club moved to a rink in suburban Ardmore in the 1930s. It leased, then sold, its Schuylkill headquarters to the Philadelphia Girls Rowing Club. Today, this building and the Sedgley Club (built in 1892) are situated at the end of what has grown into Boathouse Row. Toward Fairmount, there stand the Undine Barge Club (1882), Penn Athletic Club Rowing Association (1873), College Boat Club of the University of Pennsylvania (1875), Vesper Boat Club (1865) and Malta Boat Club (1870; enlarged 1880), to name but a few. Boathouse Row became a city landmark in 1976, when the riverside outlines of the buildings were strung with 10,000 light bulbs that sparkle in silhouette across the Schuylkill. National Historic Landmark recognition was given in 1987.

Sculling on the Schuylkill continues. The season opens in early May with the Dad Vail Regatta, followed by the Stotesbury Regatta on Independence Day, and then, in early October, the Head of the Schuylkill, also known as the Eakins Regatta, after Thomas Eakins, the famous Philadelphia painter who captured the essence of sculling on the Schuylkill.

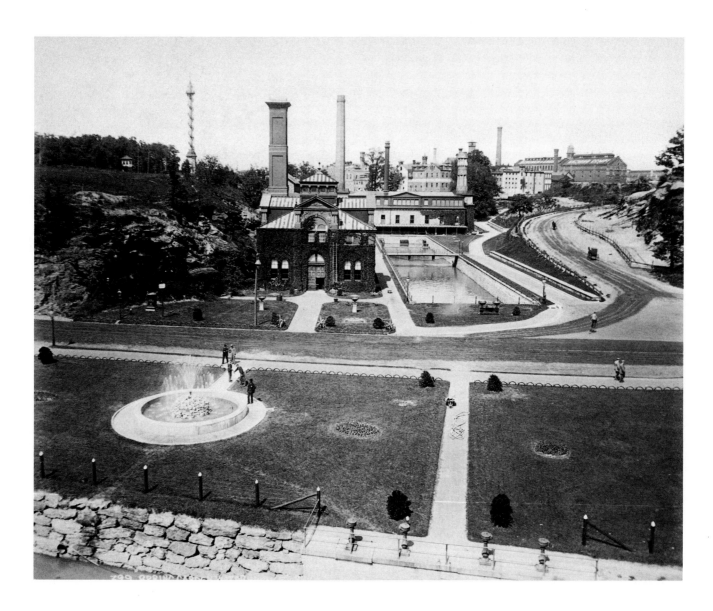

East Bank of the Schuylkill River, from the Girard Avenue Bridge, ca. 1892

Spring Garden Waterworks and East River Drive.

A road sauntered alongside the Schuylkill, upstream from Fairmount, until it reached an outcropping of mica schist called Promontory (or Turtle) Rock. There, in the mid-1840s, the inland townships of Spring Garden and Northern Liberties, which stretched to the east, carved out a long, narrow basin and pumped water from the Schuylkill to it, then to a reservoir at Twenty-fifth and Master Streets. Philadelphia County had not yet consolidated into the present city; the townships had paid a premium for Fairmount water. Their solution, much to the consternation of the city engineers, was for the townships to build their own waterworks upriver. The new Spring Garden Waterworks seemed picturesque to pleasure-seekers, but it meant that the city had to watch its water supply carefully.

East Bank of the Schuylkill River, from the Girard Avenue Bridge, 1987

Glendinning Rock Garden and Kelly Drive.

The development of the Schuylkill River Valley had four phases: for residences, industry, recreation and transportation. First, country retreats lined the bluffs. Then, by the mid-nineteenth century, many of these houses became inns, and the riverbanks were built up with icehouses, breweries and sawmills. This industrialization came to a sudden halt when Fairmount Park was extended in the 1850s and 1860s. Mills were demolished and the land returned to its natural state. But the one remaining task was to make the primitive river roads viable for modern transportation. A tunnel was blasted through Promontory Rock by June 1871, uniting the two parts of the Kelly (formerly East River) Drive. East of the tunnel are the romantic ruins of the Spring Garden Waterworks. But turn around and there lies the reason for the constant din: traffic on the Girard Avenue Bridge for cars and trolleys (originally built for the Centennial Exhibition), the Connecting Bridge for railroads and the Schuylkill Expressway.

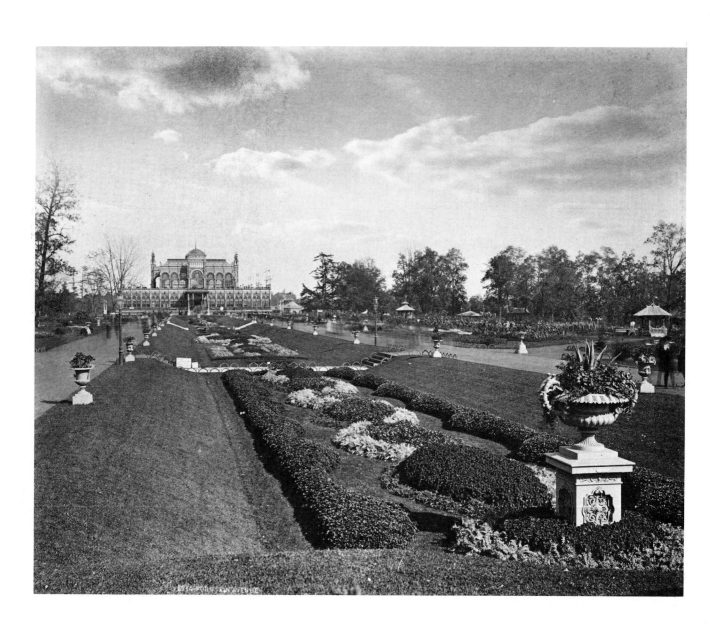

West Fairmount Park, 1876

The Centennial Exhibition's Horticultural Hall, with sunken parterre.

Within two years of ground breaking on July 4, 1874, the Centennial Exhibition's nearly 250 buildings were erected on the flattened fields of West Fairmount Park. One exhibition building covered 20 acres. Horticultural Hall, the fifth-largest in the Exhibition, was actually the largest conservatory of its time. The City of Philadelphia bore the $370,000 cost of its construction, carried out under the supervision of architect Hermann Schwartzmann. The polychromatic red, black and cream brick arches of the interior, the four cast-iron ornamental staircases, the spectacular chandeliers and the marble fountain upstaged the botanical displays. In fact, visitors often needed soothing refuge from the Centennial's overwhelming didactic displays. A writer for the *Atlantic Monthly* agreed that one "who soon wearies of palms and cactuses and unattainable bananas" might simply enjoy the building.

Near Belmont Avenue, West Fairmount Park, 1987

Horticultural Center grounds.

Where the nineteenth century aimed to include exuberance, the twentieth century aimed to eliminate extravagance. The unfortunate target for the Park Commission of the 1950s was Horticultural Hall. Concern over the costs of heating park buildings made the Hall an architectural albatross. When some of its glass panes were damaged by Hurricane Hazel in October 1954, the Commission decided to demolish the Victorian vestige, stirring little protest.

Centennial riches had spoiled Philadelphia. After the Exhibi-

tion closed, effluvia from its packed halls flooded the region. Exhibition cases reappeared in corner pharmacies. Exhibition buildings reappeared as railroad stations along the Main Line. The Smithsonian Institution in Washington, D.C., acquired a trainload of unclaimed exhibits, and in 1881 opened its own Arts and Industries Building with a Victorian garden. In 1987, the garden was rededicated as the Enid A. Haupt Garden, an abbreviated facsimile of the original sunken parterre in Philadelphia. The original, a fixture of the Centennial, had long been forgotten.

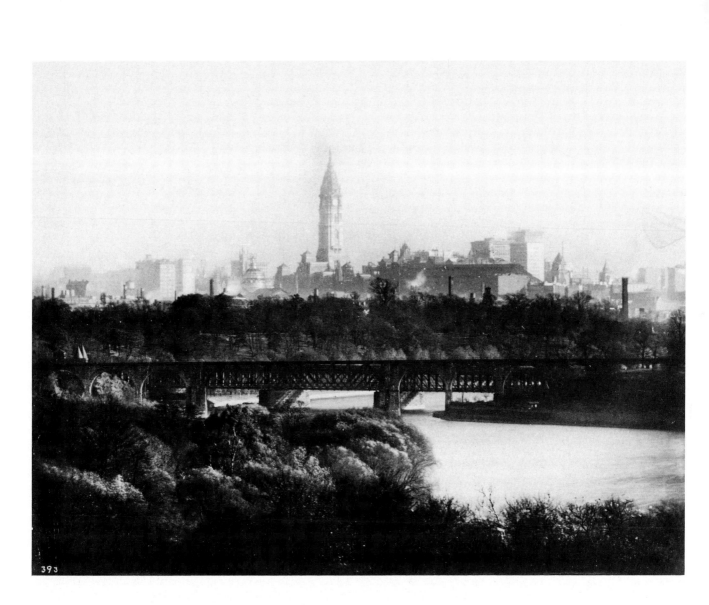

393

Center City from Belmont, ca. 1900

Schuylkill River, Girard Avenue Bridge, Railroad Bridge, skyline with City Hall.

"I can remember well when but two steeples rose about our town," orator Benjamin Harris Brewster said at the laying of City Hall's cornerstone in 1874. "Now, as you gaze from the summits in the park, the city lies before you with a number of lofty domes and skypiercing spires." Brewster was in awe of the concept of the great tower that would rise 548 feet above the spot on which he stood. And he spoke for the rest of Philadelphia.

Even early visitors to Belmont—the eighteenth-century West Philadelphia farmhouse built by the Peters family—were struck by the city view it offered. Printmakers often sold views of country houses like Belmont, but here they showed the Philadelphia skyline as seen from its front entrance. So many people came to see the vista that, beginning in 1870, the mansion supported a restaurant. Teas and meals were served for more than a century. But the tradition ended in the 1960s, when a West Coast restaurateur proposed building two new glass-enclosed ballrooms and an expanded restaurant in pseudo-Colonial style. The Fairmount Park Commission preferred to see Belmont remain unscathed by having it lie fallow.

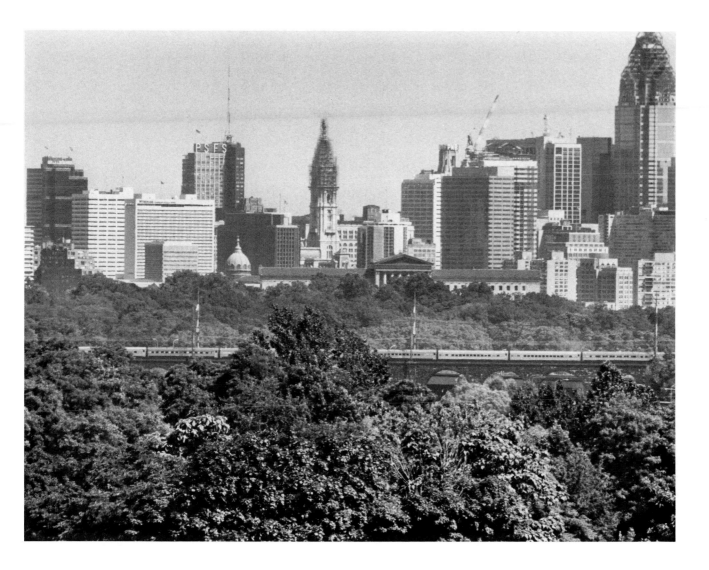

Center City from Belmont, 1987

Skyline (left to right): ARA Building, SmithKline Beckman Building, Wyndham Franklin Plaza Hotel, Philadelphia Saving Fund Society Building, City Hall, Palace Hotel, One Logan Square, One Liberty Place.

Called a "tasty little box" by one eighteenth-century visitor, Belmont is considered the gem of the remaining Fairmount Park houses. In the 1980s, it was reopened by the American Women's Heritage Society, which staved off decay while the future use of Belmont (and other park houses) was studied. As the mansion simply held on, the city before it rose to new heights.

There had been talk in Philadelphia of a "gentleman's agreement" that no building would rise taller than the tower of City Hall. But developers who noted the potential of Philadelphia's real estate argued that it was finally time for the city to venture into the twentieth century and build up. Despite a sustained protest, civic leaders concurred. Developer Willard G. Rouse III hired architect Helmut Jahn to design One Liberty Place, the first building to break the height barrier. When its steel-blue, Norway-granite facing and matching glass rose to the level of City Hall, there were still nearly 400 feet to go. Not since 1932, when the four red letters atop the PSFS building appeared on the city's skyline, had an office tower attracted so much attention.

Wissahickon Drive, Looking toward Gypsy Lane, ca. 1900

Wissahickon Hall.

Not far from the mouth of the Schuylkill River, Wissahickon Creek makes a series of dramatic turns. High ridges evoke mystery, romance and history. An attempt to replace the Indian name, meaning yellow stream or catfish creek, with one less cumbersome to English settlers—Whitpaine's Creek—failed in the late seventeenth century. When Wissahickon Drive was renamed Lincoln Drive in the 1980s, again there was a decidedly uncooperative response. The Wissahickon will always be the Wissahickon, the place of millers and mystics, romantic poets and lamp-shade artists.

"Perhaps Philadelphians do not quite realize how famous the Wissahickon Valley is," wrote Christopher Morley in *Travels in Philadelphia:*

> When my mother was a small girl in England there stood on her father's reading table a silk lampshade on which were painted the world's loveliest beauty glimpses. There were vistas of Swiss mountains, Italian lakes, French cathedrals, Dutch canals, English gardens. And then, among these fabled glories, there was a tiny sketch of a scene that chiefly touched my mother's girlish fancy It was called "The Wissahickon Drive, Philadelphia, U.S.A."

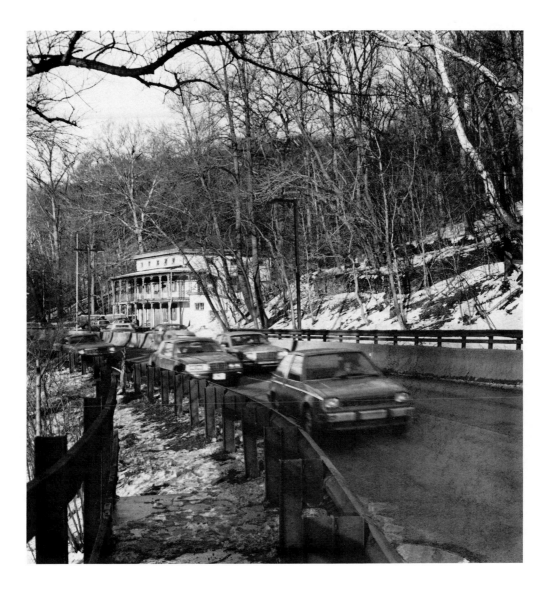

Lincoln Drive, Looking toward Gypsy Lane, 1987

92nd Police District Station House.

To a Wissahickon Valley youth in 1800, the promise of the future could be passed along in one word: waterwheels. The success of Andrew Robeson's corn mill and William Rittenhouse's paper mill seemed to make that perfectly clear. And for another 50 years, little else but mills appeared in the Wissahickon Valley. But as pollutants from dozens of its mills became noticeable in the city's water supply, parcels of land above the waterworks were added to the park system. Finally, in 1869, the six-and-one-half-mile appendage of the Wissahickon was added to Fairmount Park.

Over time, some mills were demolished; others were allowed to fall into ruins. The various inns of the Wissahickon Valley (which the city wanted nothing to do with) were closed, one by one. By the end of the nineteenth century, a once-lively tavern life was only a memory. At the close of the twentieth century, the only tavern to survive along the lower creek, Wissahickon Hall, remains as a police station.

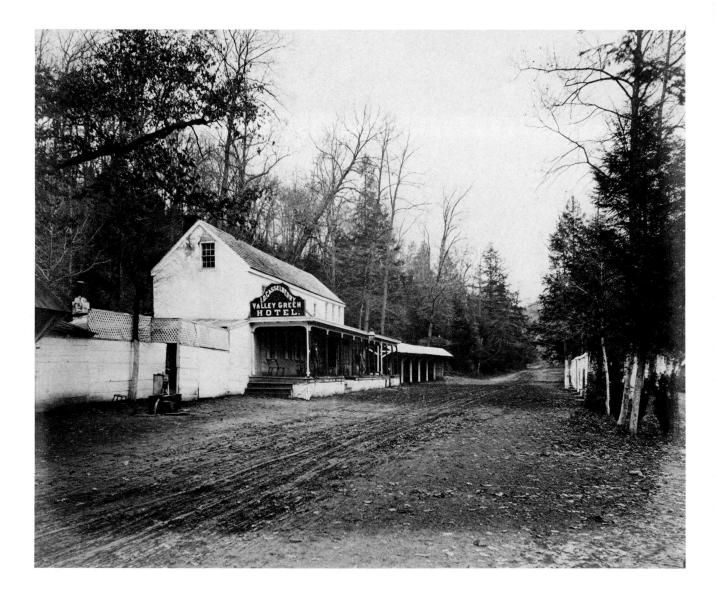

Wissahickon Drive near Valley Green Road, ca. 1875

I. D. Casselberry's Valley Green Hotel.

With no desire to go into the tavern business, the city closed the many watering holes along Wissahickon Creek. Gone were the Maple Springs, famous for its porch hung with planters carved from twisted roots; the Lotus Inn, where sleighing parties stopped to enjoy catfish, chicken and waffles; the Old Log Cabin, a remnant of the Harrison presidential campaign, which featured a barrel of cider by the door and a menagerie on display inside. Only one tavern survived: Valley Green Inn. The reason, without a doubt, was that its turn-of-the-century owners served nothing harder than tea and lemon.

The most prosperous years of the Wissahickon Valley—and the Valley Green Inn—existed after the road into the Wissahickon was completed in the 1850s. Abraham Rinker's rough-sawn dancing pavilion, built on the hemlock slope behind the inn, attracted a lively crowd. On still evenings, the dancing calls echoed across the creek and throughout the valley. Things calmed down considerably after 1901, when a patriotic women's group took over the inn. Outside, in summer, green canoes were pulled ashore near the well-tended phlox. Inside, the original country bar was no more. Here, behind the former bar, were wholesome rows of grape-juice bottles, a lemon balanced on the mouth of each one. And in the center was a large, hissing tea urn.

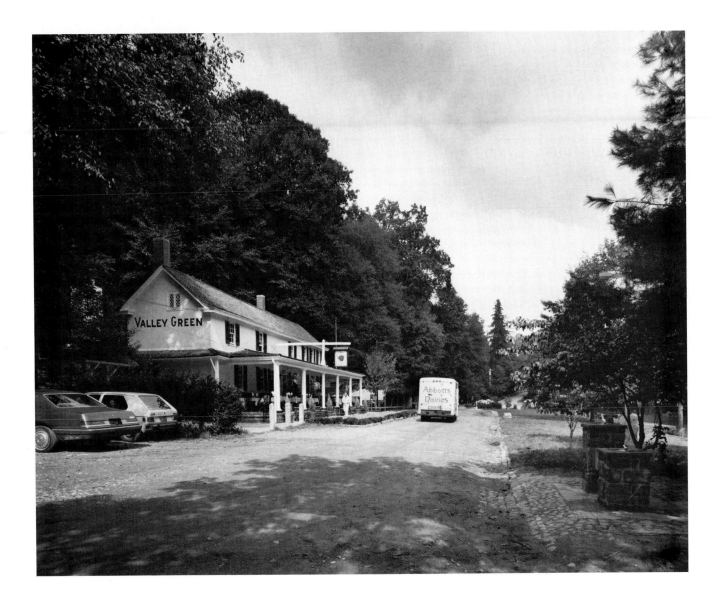

Forbidden Drive near Valley Green Road, 1987

Valley Green Inn Restaurant.

The unpaved road alongside the Wissahickon is shared daily by hundreds of walkers, runners, equestrians and bicyclists. All other through traffic is forbidden. No other place in the city is so isolated and natural. And, for several generations, the only establishment to cater to its visitors has been the Valley Green Inn. Earlier in the century, butter thins and a pot of tea could be had for $.40; a lettuce sandwich cost $.20; a club sandwich cost $.60. Dinner, as long as one chose lamb chops or sirloin steak, washed down with water, was $2.

Only in the 1980s, when civilized palates required wine, did the city restore its flow at the Wissahickon. The proprietorship of the inn changed hands in 1987 and the first new menu no longer promised mere meals, but culinary experiences. Forgotten are the catfish, the waffles and the tea urn. Here are lobster tails for $18.95, steak au poivre for $14.95 and, at $2 per cup, something from the gurgling espresso machine.

Independence Hall, South Side of Chestnut Street between
Fifth and Sixth Streets, ca. 1950

The Liberty Bell in the tower vestibule.

The bell had cracked the very first time it was heard in Philadelphia, 23 years before the signing of the Declaration of Independence. Thereafter, the flawed bell, in a rickety tower, was of little use. According to some accounts, when the Declaration was signed, just about every other bell in the city sounded. This one remained still—ironically silent. When the bells tolled the death of Chief Justice John Marshall in 1835, the rebuilt bell tower was sturdy but the bell's old crack worsened. The bell looked better than it sounded, with a poignant biblical inscription—"Proclaim Liberty Throughout All The Land Unto All The Inhabitants Thereof"—cast on its side.

The bell took on a new life when it was made part of the display in the historic Assembly Room. A decorative iron fence with classical emblems of liberty was installed around the bell, a stuffed bald eagle was placed on it. Generations of visitors encountered the bell among the Revolutionary memorabilia. In time, abolitionists called it the Liberty Bell and the name caught on. The cracked bell had evolved into an icon that would stand alone.

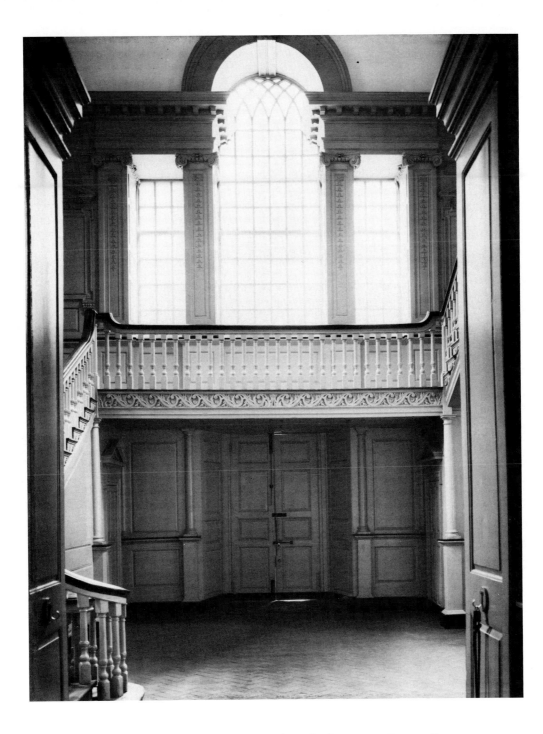

Independence Hall, South Side of Chestnut Street between
Fifth and Sixth Streets, 1986

The tower vestibule.

As an American icon, the Liberty Bell continued to draw visitors. The bell, in fact, seemed steadier than its threadbare setting in Independence Hall, which had deteriorated. During the Depression, the city began to feel the burden of Hall maintenance, and for a time stopped repairing its broken windows and replacing burnt-out light bulbs. In an attempt to find the silver lining in this historic cloud, the city proposed to sell the Hall to the federal government for $25 million. The very notion turned out to be a bureaucrat's perverse premonition of Independence National Historical Park, established in the late 1940s.

Patriotic passion inspired the park founders to refurbish the

Hall, but pure archaeology ruled the restorations. Historical inaccuracies were banished; anachronisms were hidden. More than 160 coats of paint were stripped from the exterior woodwork, revealing original tints. Air-conditioning compressors were buried beneath the sidewalk. Because authorities feared that Bicentennial crowds would literally wear out the building, a pavilion to house only the Liberty Bell was readied on Independence Mall. Crowds came out in a cold drizzle on New Year's Eve, 1975, to witness the bell's midnight procession from Independence Hall to the pavilion.

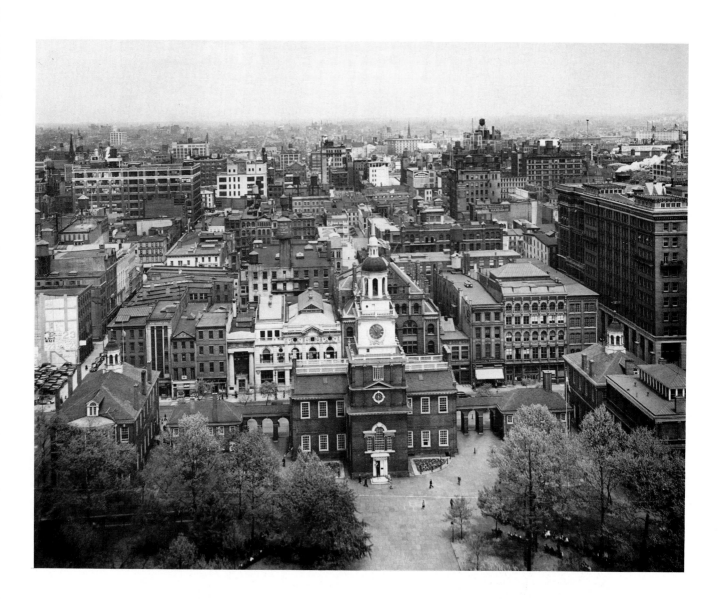

Looking North from the Penn Mutual Life Insurance Company Building, Walnut Street, between Fifth and Sixth Streets, ca. 1940

Independence Square, Independence Hall and vicinity.

In the 1730s, when master carpenter Edmund Wooley began work on the State House of Pennsylvania, some felt that the building was too far west of the center of town. And they were right, at the time. But within the next century, lots around the State House were bought and developed with a variety of commercial and residential buildings. Philadelphia's center had moved west. By 1838, when the building was a century old, a lithographic panorama made from the State House created the impression that Wooley's creation had always been at the center of Philadelphia.

Views of Independence Hall, as the State House was becoming known, were sold in quantity. The nation's painters and printmakers created in the public's mind an idealistic "Cradle of Liberty," isolated from the rest of the world, a vignette that floated on a cloud. By comparison, photographs of the real Independence Hall came as a shock; it was surrounded by uninspired commercial buildings. To conform the reality to the prephotographic fantasy, a scheme to frame the Hall with a spacious plaza was proposed for the Sesqui-Centennial in 1926, but it was another generation before a respectful, vignette-like image would be created with Independence Mall.

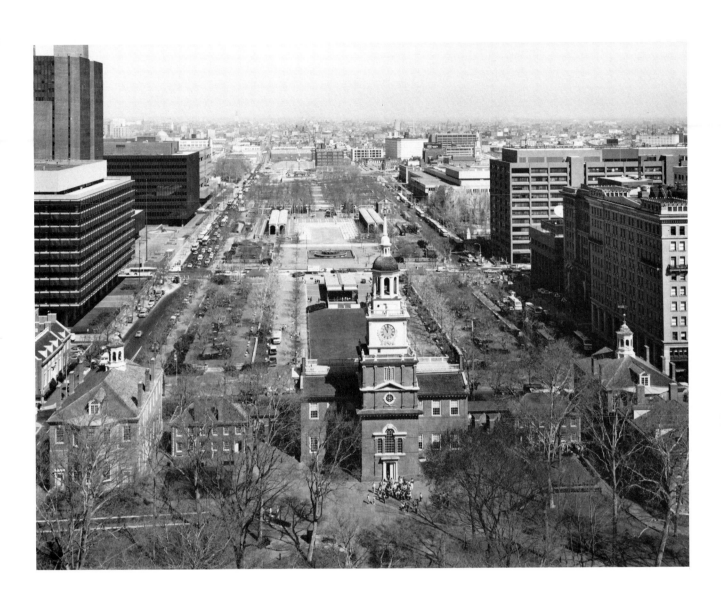

Looking North from the Penn Mutual Life Insurance Company Building, Walnut Street, between Fifth and Sixth Streets, 1987

Independence Square, Independence Hall and Independence Mall.

Congressional readiness for peacetime projects at the end of the Second World War coincided with the legislative package for Independence National Historical Park. Its time had come. Americans had long accepted Independence Hall as a shrine. The commercial value of the land adjacent to the Hall was at an all-time low and only the aesthetics of the park needed to be worked out. Planners hoped to strip away buildings that were too close and might distract visitors from the identified shrines. They would recreate settings, if necessary, Williamsburg fashion. Historians, on the other hand, were determined to preserve the historical layers and context. They feared that park land would set the shrines apart like "country churches."

In March 1948, one week before Congressional hearings were held to consider the creation of a mall, a fire opposite Independence Hall set off its sprinkler system. America's shrine was waterlogged. Now, for fear that adjacent buildings were fire hazards, the mall proposal and the stripped-down look prevailed. The federal government acquired the land east of Independence Square and the Commonwealth acquired the land north of the Square. Hundreds of buildings were sacrificed to develop the huge, L-shaped park.

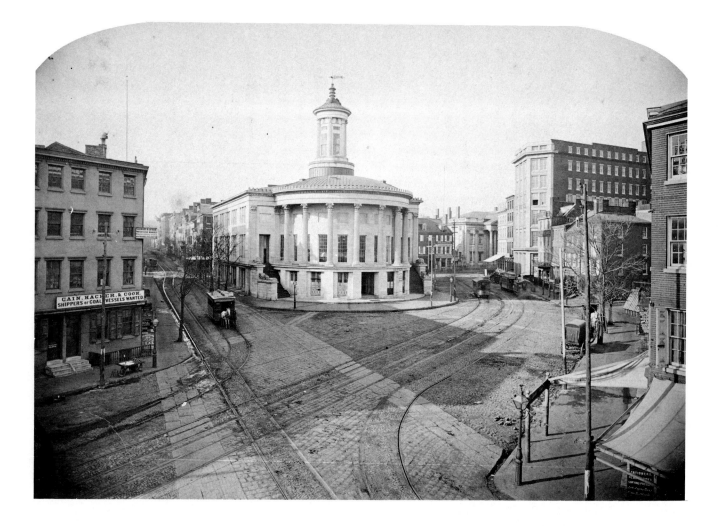

Northwest Corner, Dock and Walnut Streets, ca. 1865

Merchants' Exchange.

For more than a century, businessmen conducted their contract negotiations in whatever establishments they found between the port and banks: Local tavern owners could expect their tables to be filled with financiers and deal makers. It was a marriage of necessity and proximity.

In 1831, a group of businessmen formed the Philadelphia Exchange Company. William Strickland, who had recently made a name for himself as an architect of the popular Second Bank building, was commissioned to design an Exchange headquarters on the triangular lot at Walnut, Third and Dock Streets. Strickland consulted books on Greek archaeology and settled on a bow-front design topped by a lantern modeled after the choragic monument of Lysicrates in Athens. Local marble mason John Struthers was up to the detail involved, though the recumbent lions flanking the entrance stairs were imported from Italy. The ostentatious result contrasted with the old bars and taverns, and was more photogenic, too.

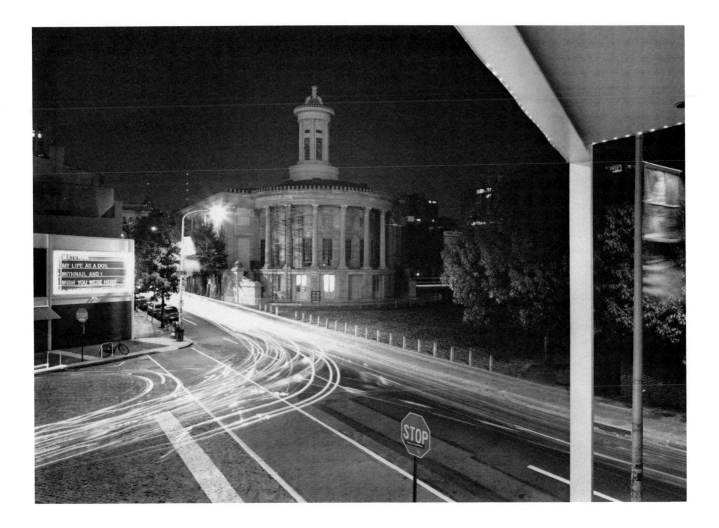

Northwest Corner, Dock and Walnut Streets, 1987

Merchants' Exchange Building: Offices of the National Park Service, Mid-Atlantic Region.

By the early twentieth century, the business and mercantile fortunes of Dock Street had migrated westward. Broad and Chestnut had inherited the bustle of trade that Walnut and Dock once knew. Although picturesque Dock Street remained intact for some time longer, it was about to undergo a transformation.

Dock Street and the Merchants' Exchange became the city's produce center in 1922. Sidewalks were covered with awnings of galvanized metal. By day, crowds, wagons and crates of fruit and vegetables brought with them an earthy brand of commerce. By night, the produce center was a deserted and Hopperesque scene. Strickland's gem was stripped of its dignity. Three decades later, the City Planning Commission, the Old Philadelphia Development Corporation and Independence National Historical Park agreed that the distribution of food from Dock Street was no longer appropriate. A new Food Distribution Center was built in South Philadelphia, and the Merchants' Exchange was claimed as Independence Park's eastern wedge into Society Hill.

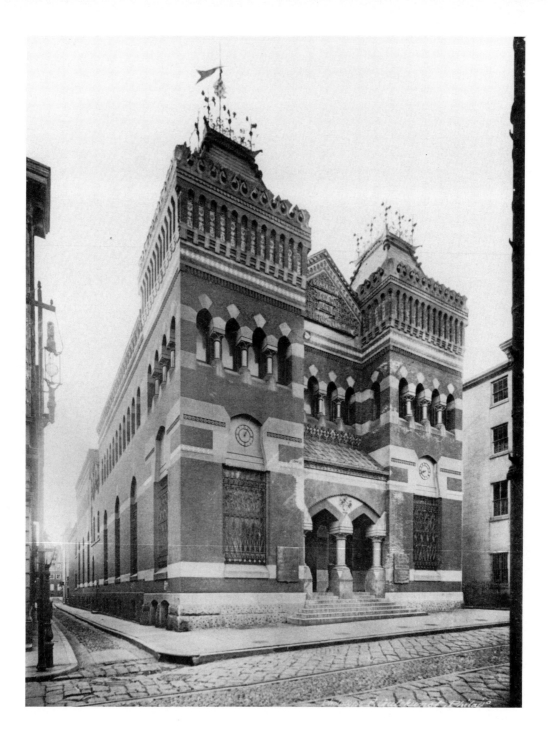

Nos. 316-320 Chestnut Street, 1885

Guarantee Trust and Safe Deposit Company, by architects Furness and Hewitt.

Whenever possible, Independence Park planners attempted to turn the clock back to the eighteenth century. This resulted in the eradication of many nineteenth-century buildings.

One notable loss was the Guarantee Trust and Safe Deposit Company, the commercial sibling to Frank Furness' and George Hewitt's Pennsylvania Academy of the Fine Arts. Its bulky polychromatic facade led to a large and colorful banking room with incised floral patterns, rich iron details and colorful tile designs. But its vintage 1875 look was from the wrong century, and it robbed Carpenters' Hall of a vista. When it was demolished in 1956, few thought of the bank's virtues. But over the next two decades, historians reevaluated Furness as one of the nation's most creative architects and considered his playfulness in difficult settings like this to be, in fact, quite sophisticated.

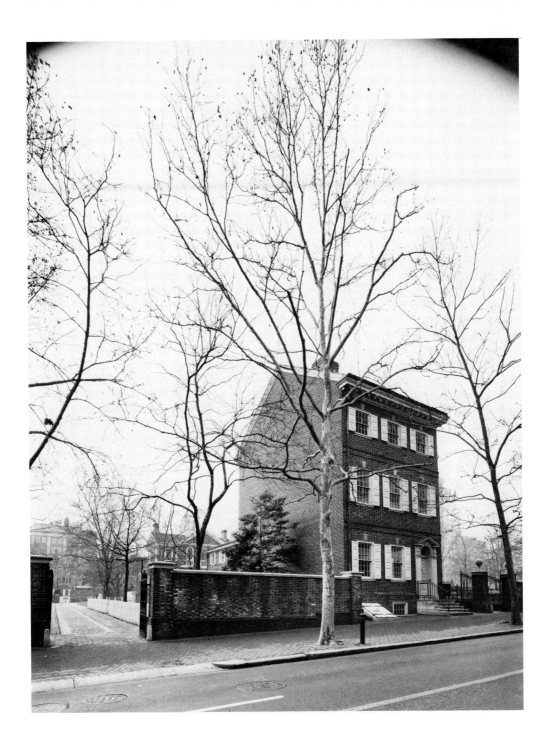

Chestnut Street, West of Third Street, 1987

Army-Navy Museum in the reconstructed Pemberton House.

In 1775, Joseph Pemberton and family built and briefly occupied a commodious Georgian house on a site purchased from the Carpenters' Company. Pemberton had married well, taught, collected books and sold Madeira. He had a committed anti-slavery view, the product of his Quaker heritage, buying slaves their freedom even in the face of his own bankruptcy. His house was not a year old, its mahogany handrail not even properly seasoned, when the Pembertons were forced to sell and move.

Twice during the American Revolution, Joseph Pemberton received draft notices. As was the Quaker practice in such situations, he paid his way out both times. A curious choice, then, that Pemberton is now remembered by a reconstructed building that serves as a military museum. The Pentagon allocated nearly $500,000 for the Pemberton House/Army-Navy Museum in the mid-1960s.

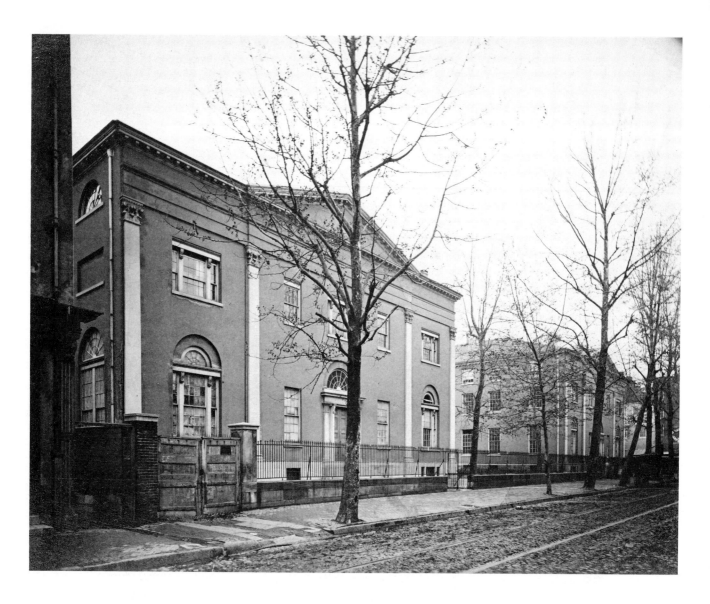

Ninth Street between Chestnut and Market Streets, West Side, ca. 1869

Campus and buildings of the University of Pennsylvania.

The University of Pennsylvania, strapped for space in its 50-year-old quarters on Fourth Street, acquired this Ninth Street site in 1800. There it expanded and, requiring even more space, demolished the original building and hired William Strickland to build these twin structures in 1829.

In the earlier building, which sold at auction for a cut-rate price, lies a tale. In the 1790s, when Philadelphia was the nation's capital, considerable thought was given to where and how the President might live. A palace seemed inappropriate for an elected leader, yet that was the tradition for heads of state. In 1791, the Pennsylvania Legislature authorized construction of a President's House. John Adams had succeeded George Washington when the house was finally completed, six years later and overbudget, but he refused to move in. (Elected officials were forbidden by the Constitution to accept gifts.) The building remained empty until it was purchased by the University in 1800.

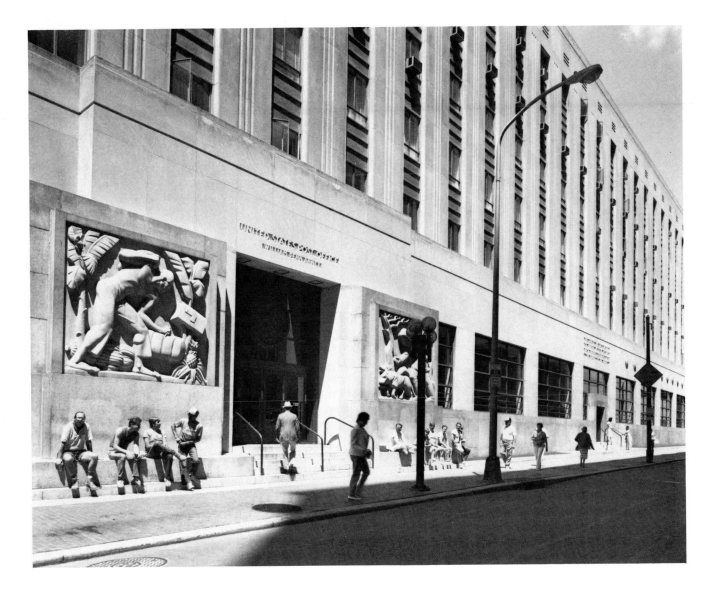

Ninth Street between Chestnut and Market Streets, West Side, 1987

U.S. Post Office and Court House.

In 1870, Provost Charles J. Stillé complained that the University's neighborhood was "vile . . . growing viler every day." Another move was at hand. The site of preference, in West Philadelphia, was measured in acres rather than in square feet, and buildings could be designed from scratch and in plenty. The Center City campus was sold to the federal government and Alfred Mullett's Victorian post office soon rose.

In the Depression, the Mullett building was demolished and architect Harry Sternfeld built a new post office in a style known as "Mussolini Modern." The building's entrances were framed with a series of stylized letter carriers by sculptor Edmond Amateis. The tropics were represented with a Gauguin-like figure, the tundra by an Eskimo, the Westerner by a cowboy, and the Easterner by a trousered citizen who might have done Norman Rockwell proud.

Franklin Institute, 15 South Seventh Street, ca. 1907

Drawing class, third floor.

In 1824, more than three decades after Benjamin Franklin's death, fire-engine manufacturer Samuel V. Merrick sought to unite the city's mechanics into an organization to educate and advocate their profession—all in the name of Benjamin Franklin. Merrick called a meeting. No one attended. He called another. Again, no response. Merrick had discovered a divided and jealous community of mechanics. But he combined efforts with a professor who was among the opposition, and called a third meeting with

exuberant results. Machinists, inventors, professors and other "useful artists" turned out in droves and the Franklin Institute was formed. The Institute held lectures, kept a library, displayed models and issued prizes. Architect John Haviland designed a building based upon the choragic monument of Thrasyllus in Athens. Aspiring architects were trained at the Franklin Institute, which offered the first architectural classes in America.

Atwater Kent Museum, 15 South Seventh Street, 1987

Storage room, third floor.

Official recognition of local history was long overdue, according to manufacturer A. Atwater Kent, a philanthropist in matters of historical preservation who wielded the family radio fortune when and where it would make a difference. In the midst of the Depression, when the Franklin Institute abandoned Seventh Street for Logan Circle, Atwater Kent purchased the old building for a museum of Philadelphia history. The Atwater Kent Museum was created by a city ordinance in 1938. Its interior was renovated by W.P.A. workers; Art Deco exhibition cases were installed on the first floor; the drawing classroom on the third floor was dedicated to storage. In more than 50 years, 10,000 artifacts, 20,000 graphics and 500,000 archaeological fragments were acquired. Treasures include the nation's earliest lace sampler (1751); the tools of Windsor-chair maker Francis Trumble, who furnished Independence Hall; and the first photographic panorama of Philadelphia, taken from the Hall's steeple.

Near Twentieth Street and the Benjamin Franklin Parkway, June 18, 1930

Ground-breaking ceremonies for the Franklin Institute.

The Franklin Institute's South Seventh Street building had been crowded from the beginning. Lecture halls, storage space for growing collections and one of the world's most acclaimed scientific libraries narrowed the aisles until a move could wait no longer. The city officially encouraged cultural institutions to move out to the new Parkway and the Franklin Institute was one of the few that complied. The site opposite the Cathedral of Saints Peter and Paul, on Logan Circle, was cleared of 57 houses and the new building began to rise.

It was more than a move. The Institute's original commitment to professional education had ended in the 1920s; the new building now housed a science museum dedicated to popular education. Its "push-button method of teaching" attracted crowds. Great locomotives, halls of optical illusions, a multistory pendulum illustrating the earth's rotation, a nickelodeon and traveling exhibitions proved popular. "Benjamin Franklin," the Institute's managers said as justification, "would have been the most enthusiastic."

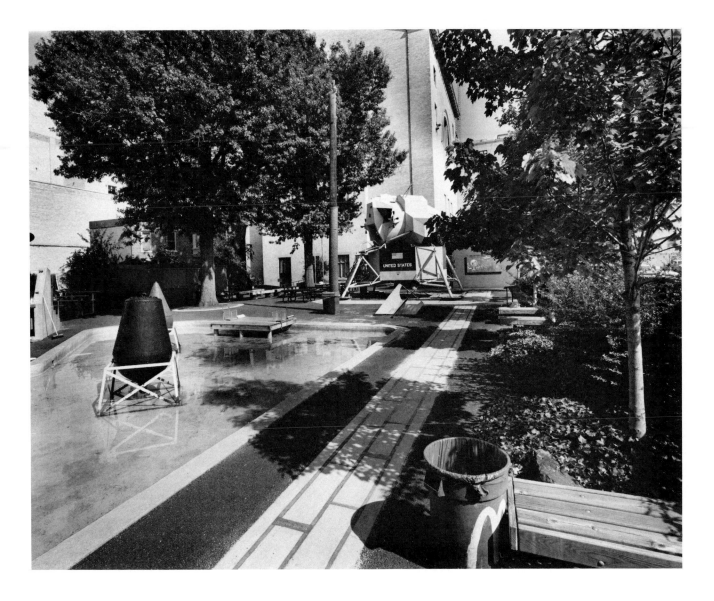

Near Twentieth Street and the Benjamin Franklin Parkway, 1987

Science Park behind the Franklin Institute.

After broadening its constituency from the community of mechanics to the community of schoolchildren in the 1930s, the Franklin Institute streamlined further. In the 1980s, it sold its rare book library, scrapped the "Foxtrot Papa" Boeing 707 and put its lunar-landing module in storage. The Franklin Institute cleared its back lot for a spring 1988 ground breaking for the "Future Center." Its centerpiece, a domed Omniverse theater, would encircle audiences with the latest in 70mm film technology. Philadelphians would be embraced by features on undersea life, energy, volcanoes, space exploration and other visually dramatic topics. Museums around the world were entering show business and getting rave reviews. The Franklin Institute aimed to get its share.

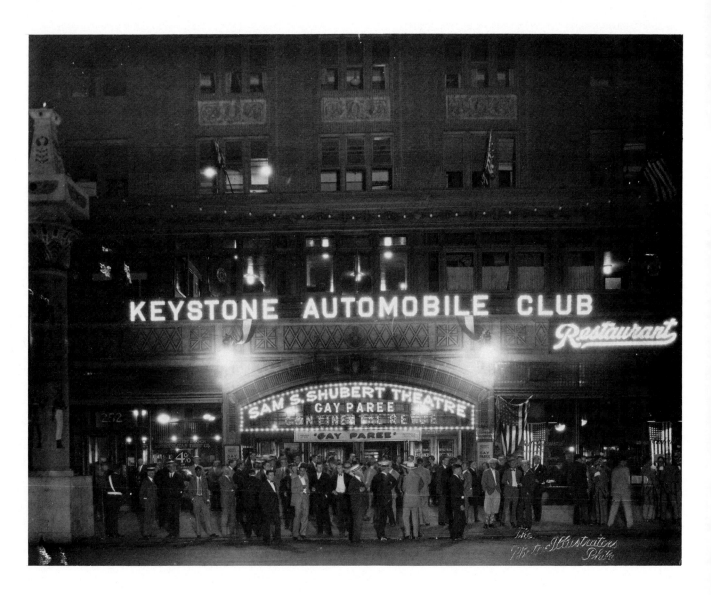

Broad Street, West Side, South of Locust Street, 1926

Sam S. Shubert Memorial Theatre with an Egyptian Revival column from the Sesqui-Centennial Celebration.

The Philadelphia stage began as flimsy booths on empty lots, featuring rope dancers, bearbaiters and archers in white pantaloons shooting targets in musical time. It was a lively community of itinerants that threatened the staid city fathers, who acted to suppress it in 1749. According to the City Council, stage folks promote "idleness and [draw] great sums of money from weak and inconsiderate people." Until these prohibitions were voided nearly a half-century later, outcast thespians kept beyond the city limits, then drawn along South Street.

The pendulum swung in the opposite direction in the nine-teenth century. The Arch, Walnut and Chestnut Street Theatres offered everything from *Macbeth* to the Albino Family from Madagascar. Hundreds of halls, minstrel shows and opera houses opened, and stars such as Edwin Forrest and Bismark ("the Pig of Genius") appeared regularly. By 1918, several of the city's 50 theaters had congregated along South Broad Street. Indeed, the Shubert Theatre opened that year with the Philadelphia premiere of *Chu Chin Chow*, featuring Florence Reed and a cast of 300 (for an audience of 1900). On South Broad Street, at least, the rise of the movie house seemed only dimly threatening.

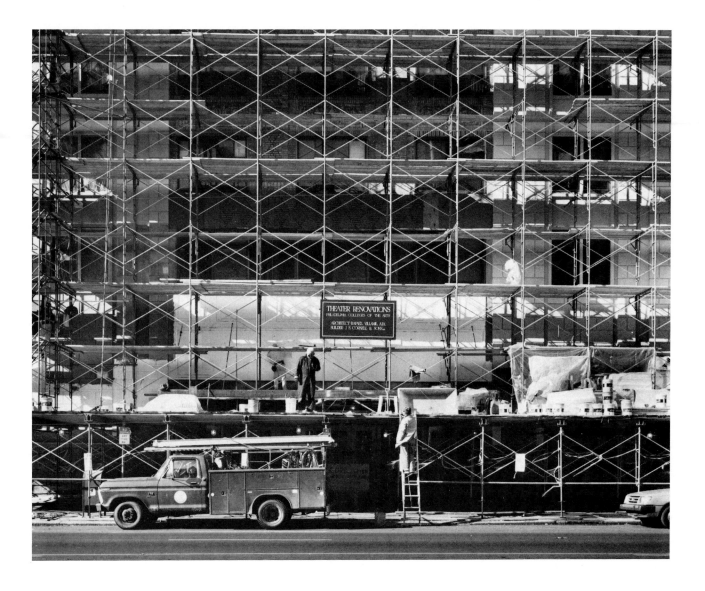

Restoration of the Shubert Theatre, Broad Street, West Side, South of Locust Street, 1987

Conversion of the Shubert Theatre to the University of the Arts Theatre.

The compact theater district suffered two casualties: Kiralfy's Alhambra Palace, directly across from the Shubert on Broad Street in the 1930s, and the New Locust Theatre, around the corner in 1980. And the Shubert's fate told of the decline of Philadelphia's affair with the stage. Architect Herbert A. Krapp's original flamboyant red and gold-leaf interior adapted well to burlesque. Its cavernous interior adapted well to Broadway-bound shows. Still the Shubert struggled like a poor relation of the stately Academy of Music, just next door.

In the 1980s, the University of the Arts acquired the Shubert and hired architect Rafael Villamil to remake the theater. He toned down the garish interior to a simple rose color and replaced badly restored murals. He made leg room, Krapp's bane, a priority. The facade was redone in a post-Modern scheme that featured, for the first time on Broad Street, plastic foam pilasters. The show went on.

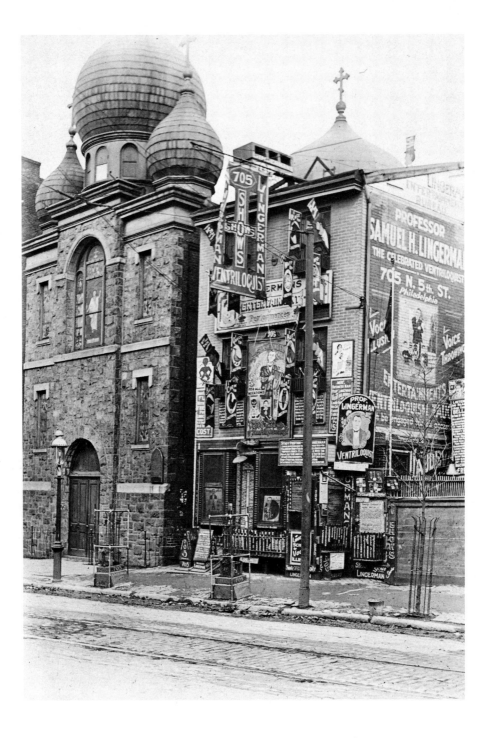

Fifth Street North of Spring Garden, ca. 1923

Saint Andrew's Russian Orthodox Church and Samuel Lingerman's Magic Emporium.

Antonio Blitz, Philadelphia's great Victorian ventriloquist, was known on stage for his learned canaries (which amazed audiences) and in the marketplace for his habit of terrorizing poulterers by making their recently slaughtered chickens seem to speak. In a world where such entertainers were usually itinerant, Blitz settled in stable Philadelphia, becoming the favorite home-town prestidigitator, and served as the inspiration to magicians who followed.

In the old urban village of Northern Liberties, adjacent to the Russian Orthodox Church on Fifth Street, lived Samuel H. Lingerman. And there, from 1903 to 1927, he vied to become Philadelphia's venerable ventriloquist. Lingerman's attention-getting signs no doubt shocked the neighborhood's recent immigrants from Eastern Europe. But they would soon make their way into Lingerman's magic emporium—for a show or a lesson or a reading of their luck in the New World by palmist Lucy Lingerman.

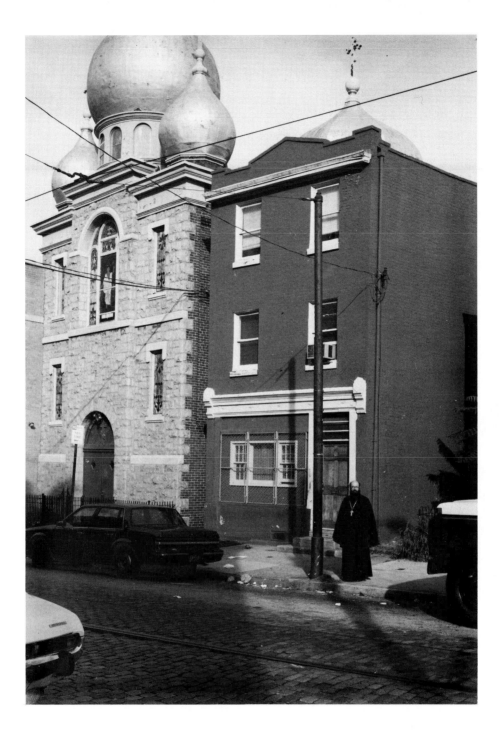

No. 705 North Fifth Street, 1987

Saint Andrew's Russian Orthodox Church, with Father Mark Shinn.

Of Philadelphia's thousands of Eastern European immigrants, many were Russian Orthodox, coming from Galicia, Central Russia and Byelorussia. In 1897, they formed a church and were determined to build in the traditional style. American architect Clyde Smith Adams merged the congregation's demands for Russian forms with regional materials to create a kind of architectural assimilation in the heart of Northern Liberties.

At the celebration of the church's ninetieth anniversary in 1987, its balalaika orchestra played and remnants of the now-extinct weaving crafts were brought out for display. More than ever, the sense of community was tied only to the church, for all of the congregation's remaining 120 families had moved from the neighborhood to southern New Jersey and northeast Philadelphia. Northern Liberties had long since declined into a gritty industrial neighborhood. In the 1970s, artists found its historical layers appealing and affordable, paving the way for gentrification in a neighborhood where Saint Andrew's had long been a cornerstone.

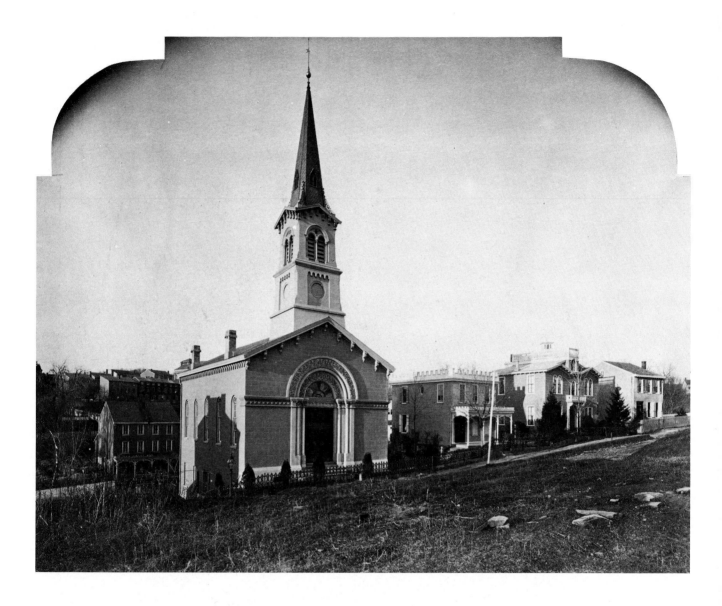

Indian Queen Lane above Ridge Avenue, ca. 1870

The neighborhood of Falls of the Schuylkill (or East Falls) with the Falls of the Schuylkill Baptist Church.

The first village upstream of Fairmount was a small, mostly industrial place called Falls of the Schuylkill. Great boulders spanning the river there appeared to be convenient as bridge foundations. But bridges were washed out, one after another, by annual floods or destroyed by annual ice. These bridges, it seemed, provided better conversation than transportation. The village grew tightly on the steep slope up from the mills; everyone lived within earshot of the rushing water. The prolific catfishermen who stocked the tanks and ponds of nearby taverns heard it best as it tumbled over the smooth boulders. Those who worked in the mills on the hillside barely heard it. But in 1821, when the dam at Fairmount caused the river to rise slowly and permanently submerge its boulders, the Falls of the Schuylkill faded until they made no sound at all.

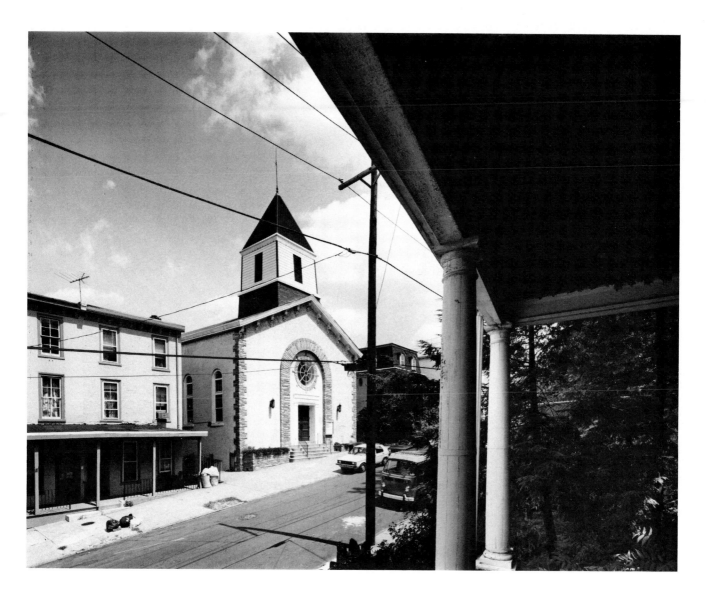

Indian Queen Lane above Ridge Avenue, 1987

Falls of the Schuylkill Baptist Church.

As the falls disappeared, so did the springtime ritual of catfish-and-waffle suppers. The river ran calmly, muddily and with relatively few catfish above the Fairmount dam. If not for the retired fishermen's propensity to weave tales of their phenomenal all-night catches, residents of the falls might have forgotten this lore.

The catfish were gone in the twentieth century, when the neighborhood fell on hard times. The congregation of the Falls of the Schuylkill Baptist Church, attended from the 1850s by local brickyard and factory workers, dwindled in the 1980s to a dedicated 45 members. Meanwhile, an entrepreneurial urge in the neighborhood resulted in gentrification. New "fish" stories begin to replace the old ones. Real estate, underpriced by Center City standards, was "developed" by moguls who cast out investments and hauled in an annual 40 percent increase in value. They talk of their "catches" at a local urban professional's tavern, which, by no coincidence, serves farmed catfish.

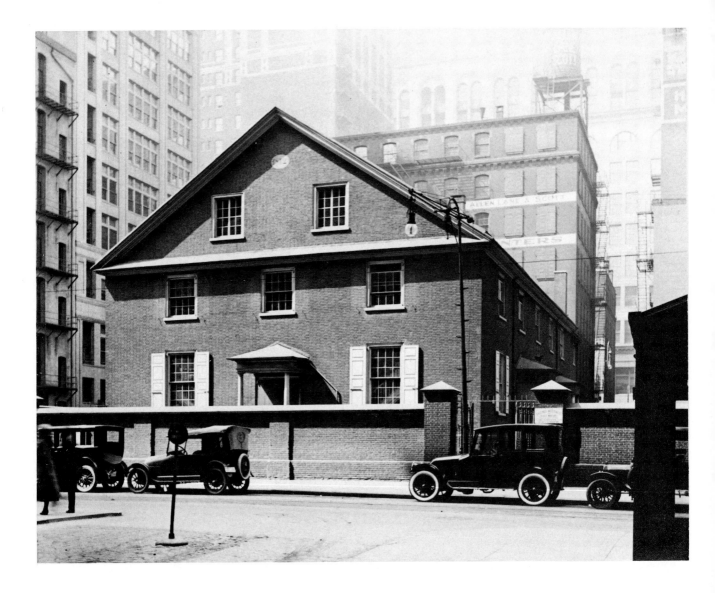

No. 20 South Twelfth Street, ca. 1923

Twelfth Street (Friends) Meeting House.

William Penn envisioned Philadelphia complete and finished, though he did not leave exact instructions as to how this end would be achieved. To the early settlers along the Delaware, it seemed impossible that this future metropolis would be centered at the intersection of Broad and Market Streets, but they agreed to build there anyway. In 1694, when Penn's plans for a Meeting House at Center Square were actually carried out, a mile of mud and meadow separated it from its congregants. The operative principles at work here were surely faith and obedience, not town planning. The early Meeting House at Center Square, however, was dismantled in 1702. Structural elements from it were hauled back and reused in a more conveniently located meeting on Front Street near Arch, signifying that Philadelphia filled out at a much slower pace then Penn had foreseen.

In 1812, when the Twelfth Street Meeting was built, the city was only beginning to show promise of growth that far west. But just as Penn had envisioned, the city grew up and the site seemed perfect. Only progress in the twentieth century numbered the days of the Twelfth Street Meeting. Little matter that Elias Hicks preached there. Little matter that the American Friends Service Committee was founded there in 1917, and that other groups, including the Urban League, SANE (Citizens for Sane Nuclear Policy), NAACP (National Association for the Advancement of Colored People) and Women Strike for Peace had grown there. The adjacent bank was willing to pay $810,000 for the site.

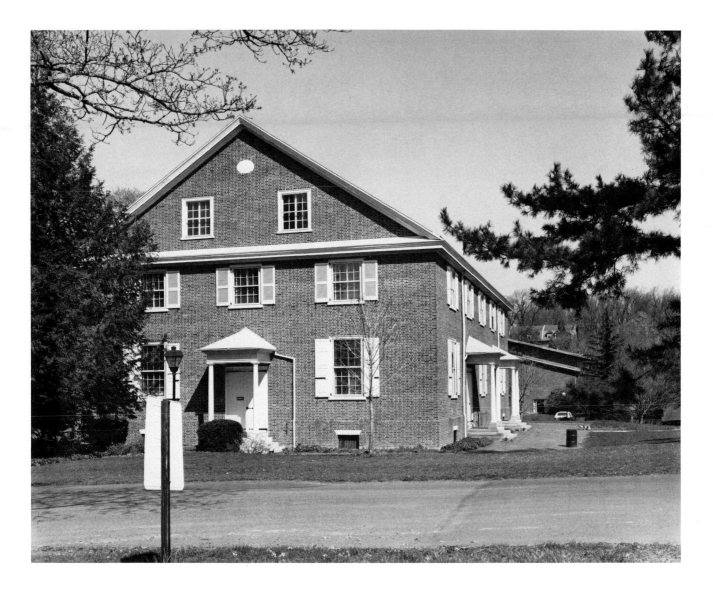

George School, Newtown, Bucks County, Pennsylvania, 1987

Friends Meeting.

It was abhorrent to consider that the great and modest hall would be eliminated for any sum of cash. As soon as the intent to sell was announced in 1970, ideas for reuse were proposed. It could become a visitors center for Independence National Historical Park. It could be moved and incorporated with the Fifteenth Street Meeting, which had agreed to subsume the Twelfth Street Meeting. It could be moved to Front and Spruce Streets for some uncertain future reuse. The idea of moving the Meeting somehow convinced Philadelphians that this was not going to be a typical loss.

But Philadelphia did lose the building. It was accepted by the George School in Bucks County, which rebuilt the Meeting House between its tennis court and baseball diamond, and held a dedication at the beginning of the school year in 1974.

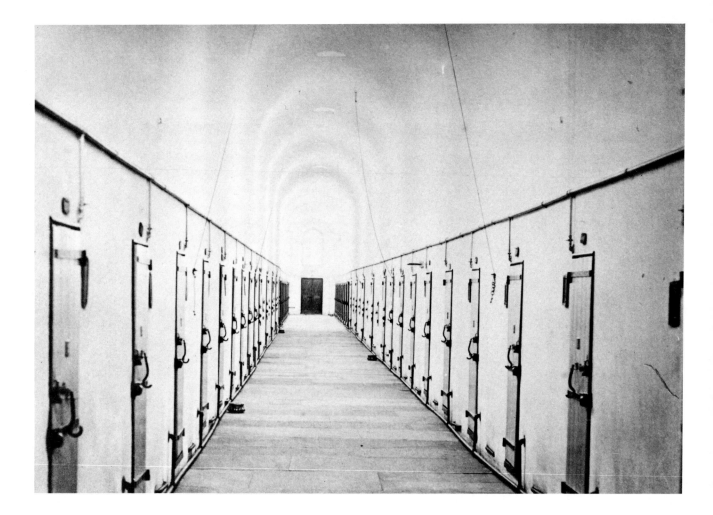

Eastern State Penitentiary, Fairmount Avenue and Twenty-Second Street, 1872

First block, from the central rotunda.

Obligations to humanity "are not cancelled by the follies or crimes of our fellow creatures," agreed members of the new Society for Alleviating the Miseries of Public Prisons in 1787. Government had no business confining debtors with murderers, on chain gangs by day and in cold, damp dungeons by night. Philadelphia's social reformers were inspired by Quaker idealism, and they wanted change.

Reform was finally won in 1821, when ground was broken on 11½ acres of farmland about a mile northwest of the center of town. At the spacious Eastern State Penitentiary, inmates were isolated with little but conscience and Bible in sky-lit cells and adjoining yards. Its seven corridors, radiating from a central rotunda in a star-shaped plan, forged a unique relationship between architecture, planning and new social theory. Architect John Haviland's utopian penitentiary grew into an international tourist attraction. Charles Dickens and Alexis de Tocqueville came to Philadelphia to tour Eastern State, as did architects, who adapted its radial plan to hundreds of penitentiaries around the world.

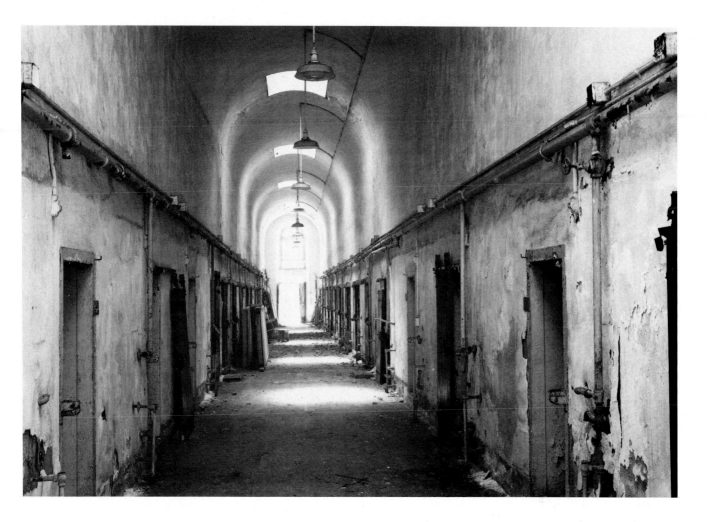

Eastern State Penitentiary, Fairmount Avenue and Twenty-Second Street, 1987

First block, from the central rotunda.

Could a criminal be reformed? Debate had raged in England and America over the likelihood of such a possibility. Would a reform approach—isolation with one's conscience and a Bible—bring on penitence? Though Philadelphia's liberal idealists were ready to experiment, London cynics had no such faith in humanity. They preferred to isolate unwanted members of society by transporting them to faraway places like Australia. Charles Dickens—a subscriber to the transportation method and a vehement critic of the Pennsylvania system—visited Philadelphia in 1842. He was taken to the cell of a fastidious German who grabbed at his coat, wept and pleaded. "I never saw or heard any kind of misery that impressed me more than the wretchedness of this man," wrote

Dickens, smug to have found so apt a case with which to illustrate the failure of a social experiment.

For nearly 150 years, Eastern State continued as a penitentiary. Then it was emptied, became a National Historic Landmark and remained empty. The city's most influential and intact structure— one architectural historian called it "the single most historic building in Philadelphia"—seemed to be nearly in the hands of developers imagining theme parks, shopping centers, a mini-industrial park or a Middle Eastern bazaar. In April 1988, on the eve of a decision to develop, Mayor W. Wilson Goode scuttled plans and stated: "This historical site must be preserved."

Preston Retreat, Hamilton Street between Twentieth and Twenty-First Streets, ca. 1952

"For indigent married women of good character."

In the nineteenth century, people inclined to philanthropy had a wide-open field in Philadelphia. Government offered little competition. Dozens of small and not-so-small institutions were founded with names like the Northern Home for Friendless Children, Asylum for the Relief of Persons Deprived of the Use of Their Reason, the Magdalene Society and the House of Refuge.

When physician Jonas Preston died in 1836, he bequeathed nearly $250,000 to start a "lying-in-Hospital . . . for indigent married women of good character . . . where they may be received and provided with proper obstetric aid for their delivery." Preston's was a generous and progressive idea that skirted some prevalent moralistic dilemmas. And at the time, the funds were considered equal to the task. But what money was left after architect Thomas U. Walter turned the building over to the trustees was ravaged by the financial crash of 1837. Preston Retreat became a foster home while Preston's endowment was allowed to grow. Obstetric patients were admitted three decades later.

One Buttonwood Square, 2001 Hamilton Street, 1987

Apartments with pool, spa, paddle tennis and a doorman.

Jonas Preston was more than a century ahead of his time in anticipating public-health care. The philanthropic and humanistic service originally rendered at Preston Retreat became a matter of course in the twentieth century. Soon, the Doric tetrastyle portico meant more to historians of architecture than to expecting mothers. It was demolished in 1963.

The Korman Corporation built a concrete apartment building in its place. And since the transfer of property was conducted through the Philadelphia Redevelopment Authority, developers were obliged to set aside one percent of the budget for art. In 1975, the Korman Corporation purchased Kenneth D. Snelson's stainless-steel *Sagg Main Street* and installed it on an island in the building's parking lot. It was one of 300 public works acquired by the city during nearly three decades of the Authority's One Percent Fine Arts Program.

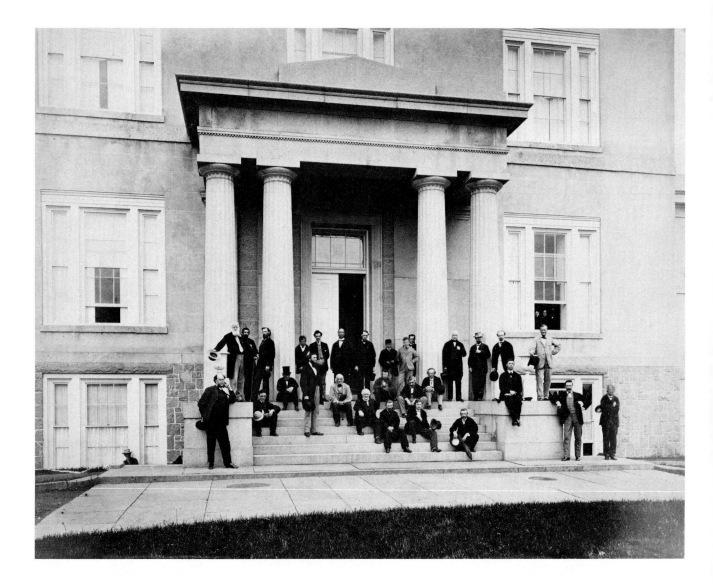

Institute of Pennsylvania Hospital, Forty-Ninth and Market Streets, ca. 1870

Psychiatric staff on the steps of the southern wing.

Treatment of the mentally ill in Philadelphia consisted primarily of confinement until a group of progressives, including Thomas Kirkbride, changed this branch of medicine. In 1840, Kirkbride began more than four decades as head of the Institute of Pennsylvania Hospital. He pioneered reforms based upon the belief that psychiatric disorders were treatable diseases. He insisted that inmates be considered as patients and receive courteous and respectful care, making their environment conducive to mental health.

Kirkbride intended to redesign the hospital. "It is very difficult for any one properly to plan a hospital for the insane, who has not had a practical acquaintance with the disease," he wrote in 1844. And within a decade, Kirkbride and architect Samuel Sloan collaborated on a new building for the Institute. Its success made Kirkbride an expert on the construction of mental hospitals. Avoid the severity of a prison, he advised, stay away from loftiness, "extravagance or excessive ornament." Build "in the country, within a reasonable distance . . . of some town of respectable size."

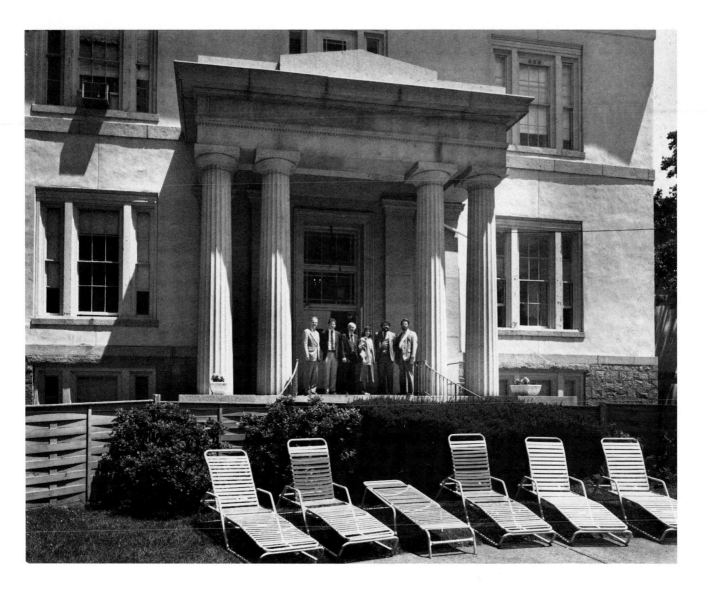

Institute of Pennsylvania Hospital, Forty-Ninth and Market Streets, 1987

Psychiatric staff on the steps of the southern wing.

With the help of local photographers, Dr. Thomas Kirkbride introduced his patients to lantern-slide shows. With the help of artists, he also introduced them to modeling in clay and painting in oils. Kirkbride also brought in lecturers, conjurers, ventriloquists and puppeteers whose performances he considered therapeutic. Today, the Institute of Pennsylvania Hospital staff includes 240 psychiatrists, social workers, nurses and therapists who engage patients in traditional and innovative therapies: occupational therapy, recreational therapy, art therapy, music therapy and pet therapy. Each year 1200 patients are admitted. The outpatient clinic treats nearly 5600. The Unit for Experimental Psychiatry conducts research on phenomena involving altered states of consciousness (hypnosis, sleep, pain) and biofeedback techniques.

Left to right are: Dr. Peter B. Bloom, Director, Continuing Medical Education; Dr. Bruce J. Levin, President, Residents' Assocation, 1986–87; Dr. Charles Dick, Secretary-Treasurer, Medical Staff, 1986–87; Molly Raphael, Vice President; Dr. Sandy D. Melnick, Assistant Medical Director and Attending Psychiatrist; and Dr. George S. Layne, Attending Psychiatrist and Curator of Photographs.

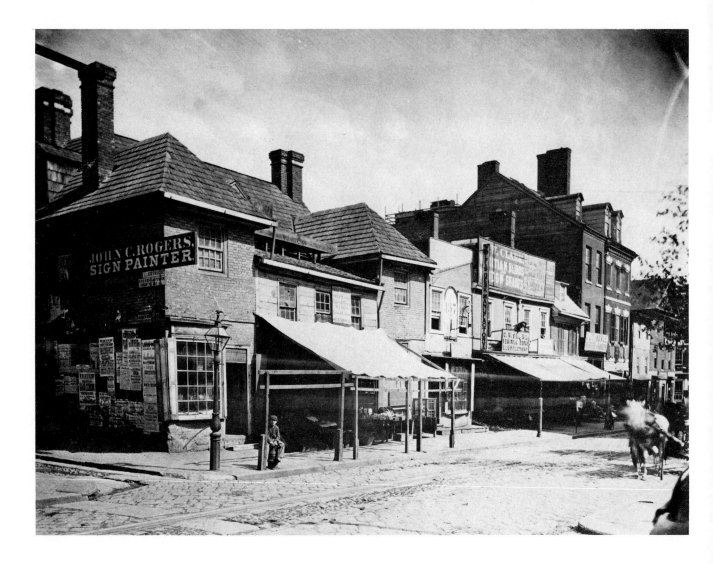

Southeast Corner of Second Street and Norris Alley, ca. 1864

The Slate Roof House, once the residence of William Penn.

When John Fanning Watson identified the city's most important historical sites in the 1820s, this "forlorn" house on Second Street especially concerned him. It was then a rundown boardinghouse, barely worth the trouble it took to rent out. But Watson traced its ownership back to 1700. William Penn had lived there.

"In those doors he went in and out—up and down those stairs he passed—in those chambers he reposed—in those parlours he dined and regaled his friends—through those garden grounds they sauntered," wrote Watson. Walking through the same thresholds as Penn had inspired an irrepressible "poetry of feeling" in him. Likewise, it made him fear "those superficial thinkers; who can only estimate its value by their conception of so much brick and mortar!" If only the Slate Roof House could be preserved, Watson lamented, "there is a generation to come who will be grateful. . . ."

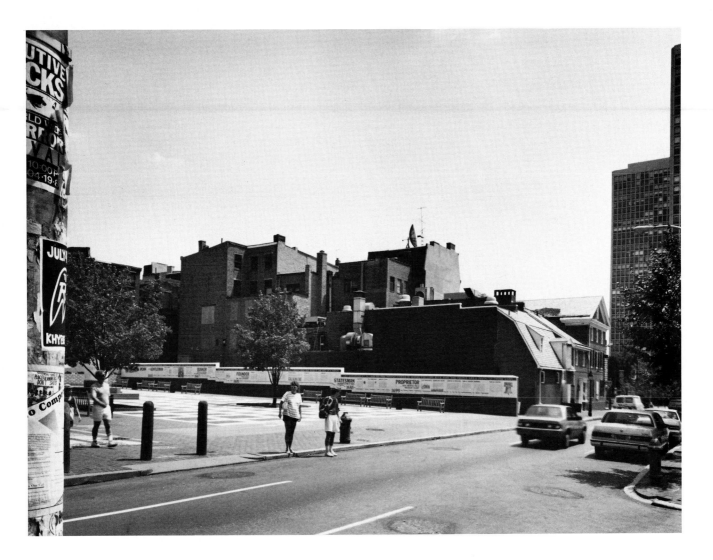

Southeast Corner of Second and Sansom Streets, 1987

Welcome Park.

No one "bought and consecrated" the Slate Roof House or, as historian Watson had hoped, restored "its bastions and salient angles." Commercial forces threatened while antiquarians pleaded for salvation, but in 1867 a group of grain-and-flour dealers acquired the building for its land. They cleared the site and built a Commercial Exchange, which nearly burned down within a year.

Additional buildings were removed in the early 1980s and the site was acquired for Independence National Historical Park with a private grant of $650,000. Reconstruction of the Slate Roof House was briefly considered. But reconstruction was by then considered ideologically unsound, as well as prohibitively expensive. Instead, the 90′ × 150′ lot was developed into the $750,000 Welcome Park, named after the ship that brought William Penn to the city. Architects Venturi, Rauch and Scott Brown laid the park out as a map of Penn's city, with streets of granite, rivers of slate, benches of teak and a didactic, museumlike label running along the long wall.

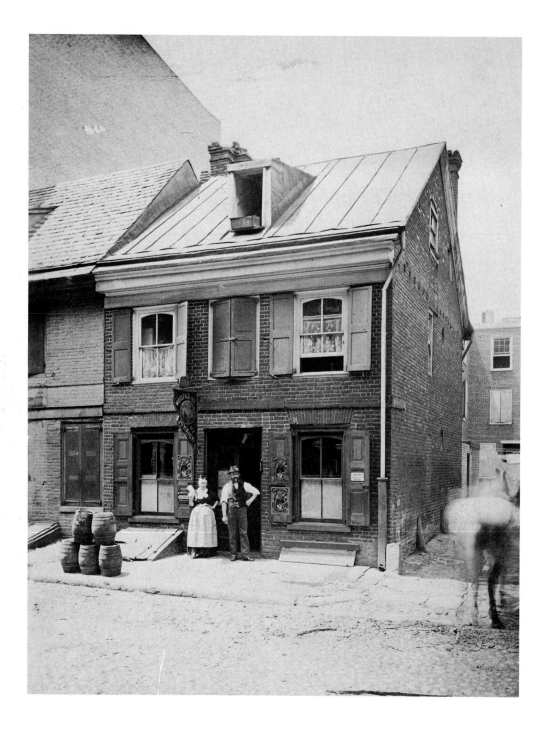

No. 8 South Letitia Street, ca. 1880

Letitia Street House, once thought to be the residence of William Penn's daughter.

Through passionate and dogged research, John Fanning Watson recreated ancient Philadelphia. He read old books, consulted old letters and manuscripts, and interviewed the city's octogenarians and nonagenarians. On the subject of a little house on Letitia Street, between Front and Second near Market, Watson believed he had made a discovery. Watson concluded that, in 1701, William Penn gave this house and a large adjacent lot to his daughter Letitia. Certain that he had identified a residence lived in by the Founder, Watson pleaded for its acceptance, preservation and conversion into a museum where Penn's desk, clock and other belongings might be on display.

Over the decades, the Letitia Street House, as it became known, developed a loyal following, swept into popularity on the coattails of the growing Penn myth. When a descendant of the Founder, Granville John Penn, visited Philadelphia in 1856 to present a wampum belt allegedly given in friendship to William Penn by the Indians, a reception was held at the little house on Letitia Street.

West Fairmount Park, near Girard Avenue and Lansdowne Drive, 1987

Letitia Street House relocated.

In 1883, on the eve of the city's Bicentennial, funds were raised to move the Letitia Street House to Fairmount Park. Before the summer was over, it reappeared across Girard Avenue from the new Zoological Gardens, overlooking the Schuylkill River. A more perfect site for a park house could not be imagined. Down to the city or up to Belmont—every direction commanded a magnificent view. For that very reason, the site had been chosen by Robert Egglesfield Griffith in the 1790s for "Eaglesfield," a stylish country estate that was demolished a decade before the Letitia Street House arrived.

A mantel plaque in the moved house reads: "This house built by William Penn A.D. 1682 is believed to have been the first brick building, erected in Philadelphia." Twentieth-century scholars did not concur with either claim. The house, it was later proven, postdates Penn's visits to Philadelphia. The Letitia Street House is "not what it was thought to be," wrote one historian. In 1965, its doors were quietly closed to tourists. Today, it serves as local headquarters of the Wildlife Preservation Trust International, Inc.

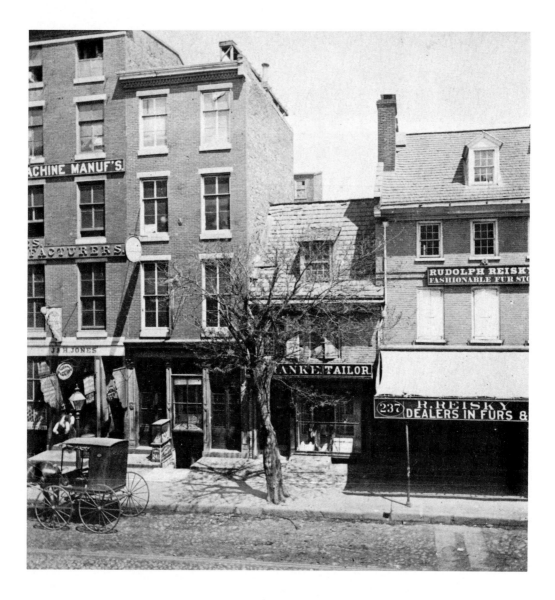

Nos. 237, 239 and 241 Arch Street, 1871

The house (No. 239, center) identified as the one in which Betsy Ross sewed the first United States flag.

As the Centennial of the nation approached, the entire slate of Revolutionary Era patriots seemed to be male. The father of the country was George Washington, but who was its mother? To fill the disturbing national vacuum, a search was begun.

Advocates of Lydia Darragh and Betsy Ross, Philadelphia's candidates, made their cases. Darragh had done some dangerous espionage and was able to thwart a British attack on an American encampment. Her house survived on Second Street near Spruce.

The descendants of Betsy Ross told the story of her commission for Old Glory. Her house stood on Arch Street. Until the Darragh house was replaced with a hotel, the two were equally strong candidates. But when Darragh's house was gone, her story began slowly to slip away from the lips of patriotic storytellers. Betsy Ross won by default. Beginning with photographer Montgomery P. Simons' view (seen here), the story of the maker of the American flag grew.

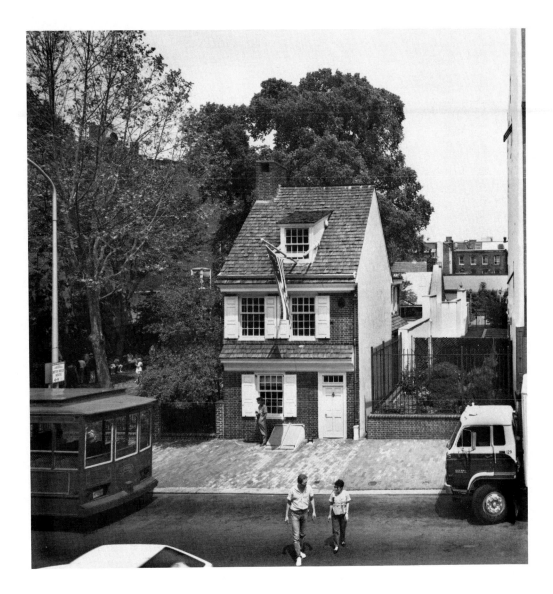

No. 239 Arch Street, 1987

The house and final resting place of Betsy Ross.

The "Old Flag House" (as its awning once read) and the story of Betsy Ross began a climb to national prominence. And as details of her life were remembered, researched and repeated, it became evident that a more perfect national matriarch could not be invented. Here was a woman who lost two husbands to the Revolution (her third marriage endured in peacetime). Elizabeth Ross Claypole died in 1836 and was buried at Fifth and Locust Streets, without any patriotic fanfare. Twenty years later, when that burial ground was sold and the caskets dug up and moved to Mount Moriah cemetery in West Philadelphia, the remains of Betsy Ross received no special consideration. However, a celebrated third interment took place in 1975, adjacent to the house.

Ross advocates saved the Arch Street house from demolition with pennies donated by America's schoolchildren. But the shrine still teetered until radio manufacturer A. Atwater Kent saved it in 1937. No matter that historians repeatedly challenged the legend as popular myth, and even questioned whether the seamstress owned that particular house. The Betsy Ross House has a devoted public. Over 500,000 visit annually—second only to the Liberty Bell.

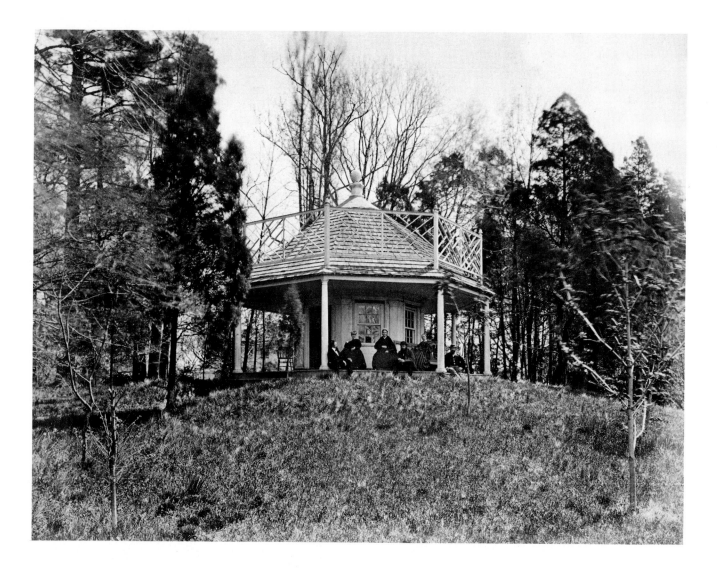

Frankford, ca. 1875

Summer pavilion of the Edwards–Womrath estate, where Thomas Jefferson was said to have celebrated after the signing of the Declaration of Independence.

Nineteenth-century patriotism spawned a myriad of myths. Their midwives were often neighborhood storytellers, history hobbyists and photographers. In anticipation of the Centennial Exhibition's souvenir-hungry visitors, photographer Robert Newell published views in series, each with a narrative caption. The premise was history; the reality was popular culture. Newell collected and served up ripened Philadelphia lore, with fact often interwoven with fiction.

Consider one such story. In the village of Frankford, five miles to the northeast of Philadelphia, lived physician Enoch Edwards. According to local legend (historians have not commented on the matter), Edwards and Thomas Jefferson were distantly related. After the Declaration of Independence had been written and signed, Jefferson ventured out from the city for a visit. On July 8, 1776, in this gazebo behind Edwards' mansion, Jefferson read the document for the first time in public. Then there was a picnic. "Ancient inhabitants of the neighborhood," recorded Newell, maintained that this was the first Independence Day celebration.

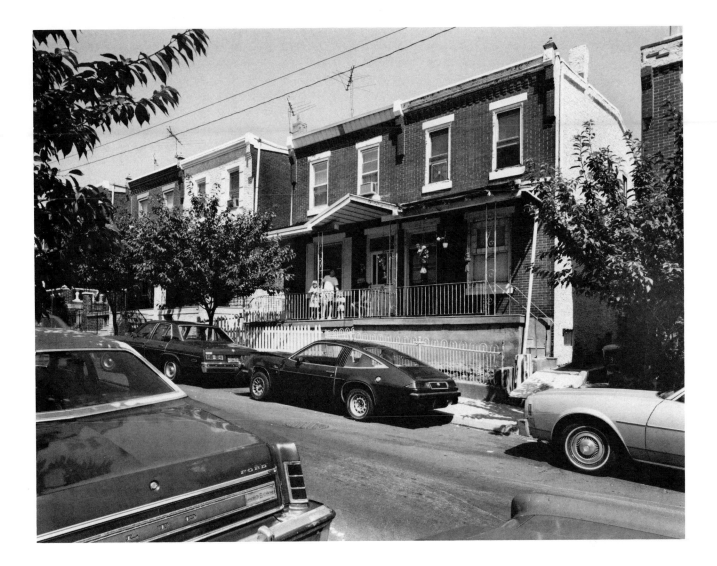

Near Ruan and Penn Streets, Frankford, 1987

Houses on the site of the forgotten Thomas Jefferson legend.

The Edwards family passed the story along to the property's next owners, the Womraths. And as long as they maintained the elm-covered hill with violets, patriotic sightseers were welcome. But Frankford was a growing industrial center at the turn of the century, home to manufacturers of such diverse products as hats, carpets, lace curtains and ship propellers. The village spread out beyond its fringes to accommodate its work force. The Edwards–Womrath estate, made famous during the Centennial of the Declaration, was not intact for the Sesqui-Centennial. A new web of streets was lined with blocks of row houses on the former estate grounds. And without the gazebo shrine on the hill, the Jefferson legend was soon forgotten.

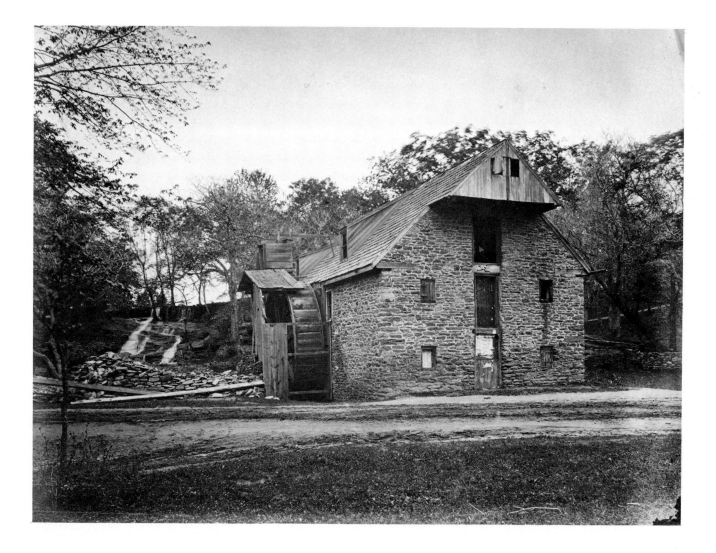

Church Lane near Wister Street, Germantown, ca. 1875

Townsend's Mill, considered the oldest grist mill in Pennsylvania.

Germantown seemed to hold onto its past with a determined grip. Indeed, not one of Philadelphia's other old villages appeared quite as ancient. Maybe it was the homespun and hearty character of mica schist, the local building stone; Center City's red brick just did not have the same aura of past times.

Antiquarian John Fanning Watson thrilled at the notion that the streets of Germantown might still be recognized by Francis Pastorius, William Rittenhouse and other early settlers. As long as old stone facades predominated on Germantown Avenue and the glimpses of the old countryside lay beyond, the antiquarian could live happily, simultaneously in past and present. One particularly ancient view—a mile out on Church Lane from Germantown's Market Square—was Townsend's Mill, considered the oldest gristmill in Pennsylvania. It was no longer in operation when Robert Newell drove his photography wagon out that way in the early 1870s. Newell, a dedicated photographic brinksman, preserved in this image what he must have known was about to be demolished.

Church Lane and Lambert Street, Germantown, 1987

Houses on the site of Townsend's Mill.

Hugh Roberts intended to do little but make flour when he acquired the mill in 1811. But about 50 years later, when the property fell to Spencer Roberts, demographics suggested other possibilities. Philadelphia's population had nearly quintupled since the beginning of the century, and by the end of the century it would more than double again. House builders were keeping pace. The city had more than 235,000 houses in the early 1890s.

Upwards of 7500 new ones were finished each year. Farmers became developers; their fields became plots. Progress had its way with the rolling landscape. The Townsend mill was soon gone, its pond drained, and the creek that fed it became a subterranean sewer beneath Lambert Street that still overflows during heavy rains.

No. 710 Green Street, 1871

Henry S. Tarr's marble mantel and monument yard.

The city's nineteenth-century architects started with a city of brick and transformed it into a city of marble. In his journals, architect Benjamin Henry Latrobe admitted that marble was one of the most readily available materials. "Now it happens to be a fact," wrote Latrobe in 1798, "that any other material besides white marble was not to be easily procured in Philadelphia. And so common is its use, that the steps to the meanest house, and cheeks to Cellar doors are frequently made of it."

Philadelphians developed a white-marble addiction that was well supplied by quarries within 25 miles of the city. People lived with white marble on and in their homes. They insisted that their public buildings be sheathed in it. As the Greek, Gothic and Egyptian Revival styles faded one into the next, only the presence of white marble remained constant. And after death, Philadelphians were interred at Laurel Hill, Woodlands or other cemeteries with properly ostentatious marble monuments.

700 Block, Green Street, 1987

Office and Daycare Center of the Spring Garden Apartments.

Demand for low-income housing grew during the Reagan years, though allocations for support did not. By 1988, federal funding of the Philadelphia Housing Authority was reduced by $22 million and the waiting list for the city's housing projects grew to nearly 9000. At the Spring Garden Apartments, the offices and daycare center are seen here; only a few of the more than 200 units are vacated each year. According to one city official, the shortage of low-income housing is to blame for the rise in homelessness. And, in the 1980s, programs to help the homeless in Philadelphia total $48 million annually.

Brewerytown, Looking Toward City Hall, ca. 1900

The southern fringes of Brewerytown, near Fairmount.

If William Penn, newly installed as a statue on City Hall in 1894, could have seen out of the corner of his bronze left eye, he would have seen his grid of streets leading mazelike to the Schuylkill. The neighborhood nearest the river, Brewerytown, had acquired its name from a beer boom in the preceding decades. The phenomenon would have interested Penn, who had encouraged German settlement in Pennsylvania and had brewed his own beer at Pennsbury, his country estate. Philadelphia's early brewers were of the British variety: Dawson, Grey, White, Abbot & Newlins. It was not until the huge wave of mid-nineteenth-century German immigration that lager yeast was smuggled into the New World. Americans liked this lighter brew. And such Brewerytown labels as Bergner & Engel, Arnholt & Schaeffer, J. & P. Baltz, F. A. Poth & Sons, G. F. Rothacker and Peter Shemm & Son soon washed out the heavier English-style beers.

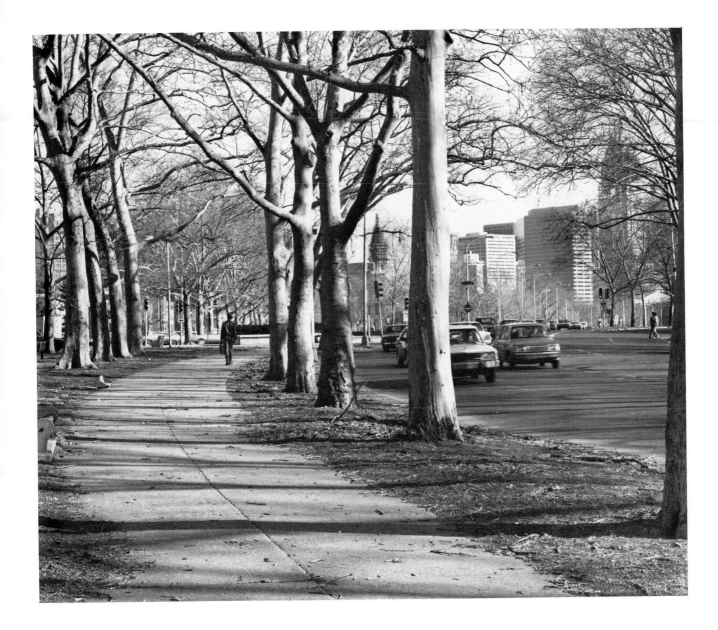

Kelly Drive near Twenty-Sixth Street, 1987

Between the Philadelphia Museum of Art and the neighborhood of Fairmount.

Under the stare of William Penn, Brewerytown flourished. But within the next generation, the Parkway that was named after Benjamin Franklin cut through the northwestern quadrant of the city. "Eat not to dullness," Franklin once advised with his usual paternal air, "drink not to elevation." The brewers, therefore, might have seen their fate coming.

Franklinian technology—in this case, refrigeration—gave highly capitalized breweries the edge over the many smaller ones. Brewerytown's labels diminished. But an even greater factor was the temperance movement, which also partly developed from early sentiments like Franklin's. And around 1919, the same time that Prohibition went into effect, the newly landscaped East River Drive shaved off a piece of sullen old Brewerytown, now a quaint segment of the larger neighborhood of Fairmount.

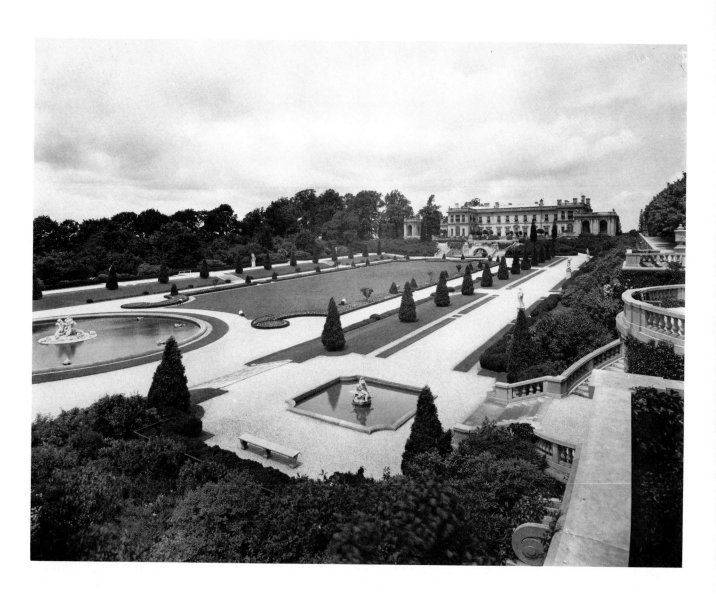

Wyndmoor, Pennsylvania, ca. 1924

Whitemarsh Hall, the country residence of Eva and Edward T. Stotesbury.

Old money had its claim to the Main Line, west of the city. New money found company in the northern suburbs where palatial estates were, in a fashion, paid for with hats (Stetson), ice cream (Breyer), magazines (Curtis), and oil and transportation (Elkins). Each was more opulent than the previous. But none outdid Whitemarsh Hall, paid for by money made with money. Edward T. Stotesbury, who built Whitemarsh Hall with his wife Eva, headed Drexel and Company, part of J. P. Morgan's empire.

The Stotesburys' Rittenhouse Square mansion, it seemed, was not quite enough for entertaining in the new grand style. In 1917, they commissioned architect Horace Trumbauer and landscape architect Jacques Gréber to convert more than 300 acres of rolling Montgomery County farmland into one of America's most flamboyant estates. Three million dollars and three years later, the Stotesburys motored past the massive entry gates down two miles of white gravel drive. They had arrived in style. Whitemarsh Hall had 153 rooms, 28 bathrooms, three elevators and separate apartments for guests, who were each assigned a servant and chauffeur. Neither princes nor presidents, cardinals nor comics, declined a Stotesbury invitation.

Wyndmoor, Pennsylvania, 1987

Behind the houses of Duveen Street, Stotesbury Estates.

Whitemarsh Hall required a staff of 150 and, in 1929, $1 million for annual upkeep. As long as someone was willing to finance the house and gardens, Whitemarsh Hall was beautiful and its future was secure. But Edward T. Stotesbury died at the age of 89 in 1938, and Mrs. Stotesbury soon closed the house and moved to Palm Beach, Florida. A long decline set in.

If grand houses could be well-connected, Whitemarsh Hall certainly still was. During the Second World War, it became the accepted safe haven for paintings from New York's Metropolitan Museum of Art. After the war, the Pennsylvania Salt Company, promising to keep up the formal gardens, converted Whitemarsh Hall into a research laboratory. After 17 years in a chemical purgatory, the estate was abandoned. Land had already been sold and developed with tracts of California-style bungalows. For another two decades, the Hall sat vacant. Sightseers, vandals and realtors visited until 1982, when the building was demolished for more development.

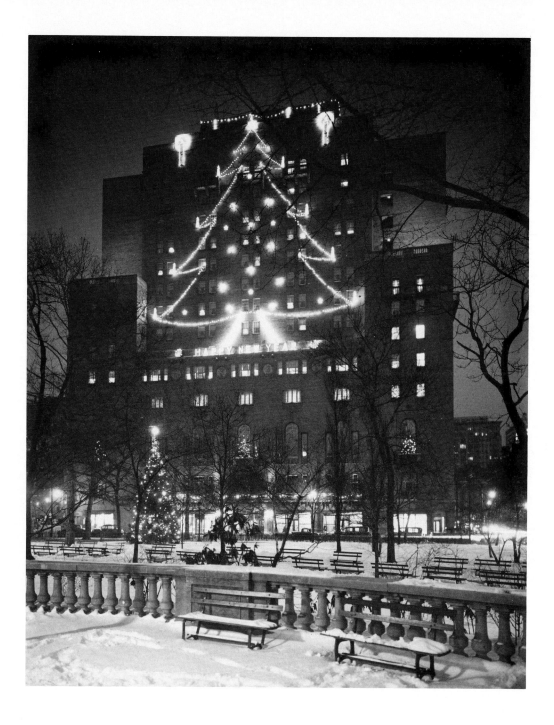

Rittenhouse Square, ca. 1928

Penn Athletic Club lit for the holiday season.

Rittenhouse Square had done quite well for itself. In the nineteenth century, old money alighted in mansions that offered views of its trees, before being lured to the more plentiful trees of the Main Line. A legacy of public art on the square has been appreciated by generations of neighbors. Children have been horrified by Antoine-Louis Barye's bronze *Lion Crushing a Serpent,* charmed by Paul Manship's *Duck Girl,* and delighted by Cornelia Chapin's *Giant Frog.* And since 1919, they have adored Albert Laessle's *Billy,* the climbable goat.

When real estate became too pricey, the residences of Rittenhouse Square were replaced by taller buildings. The Eighteenth Street mansion of locomotive manufacturer Joseph Harrison, built in 1852, was replaced by this enviable clubhouse for the Penn Athletic Club. When it opened in 1928, more than 10,000 joined. But the Depression diminished its success. In the Second World War, the United States bought the building for its Signal Corps.

Rittenhouse Square, 1987

Seventy-third annual Flower Market.

William Penn's plan for Philadelphia called for five public squares. All survive today, though four have been compromised. At the heart of the city is Center (or Penn) Square, which lasted as a park until the city needed a new City Hall. To the northwest is Logan Square, which survived until city planners remolded it into a handsome traffic circle. To the northeast is Franklin Square, from which the bridge to Camden launches eastward. To the southeast is Washington Square, which always looks like a poor sibling of the adjacent Independence Square. To the southwest is Rittenhouse Square, the closest thing to an original square that Philadelphia has kept.

With the help of the Rittenhouse Square Improvement Association and other groups, the Square has sustained an active relationship with the community. The Flower Market, first organized in 1914, benefited the Children's Hospital and the Hope Day Nursery; 73 years later, the Children's Seashore House was one of the beneficiaries. The Flower Market and the Clothesline Art Exhibit, initiated in 1932, are annual rites of spring in Philadelphia. After more than 300 years, remnants of William Penn's "greene Country Towne" still thrive. Rittenhouse Square, then as now, is a symbol of that vision.

Index of Selected Buildings and Locations